Forgotten Tales of
Rhode Island

Jim Ignasher

THE
History
PRESS

Published by The History Press
Charleston, SC 29403
www.historypress.net

Copyright © 2008 by Jim Ignasher
All rights reserved

Cover design and internal illustrations by Marshall Hudson.
First published 2008
Second printing 2010

Manufactured in the United States

ISBN 978.1.59629.586.5

Library of Congress Cataloging-in-Publication Data
Ignasher, Jim.
Forgotten tales of Rhode Island / Jim Ignasher.
p. cm.
Includes bibliographical references and index.
ISBN 978-1-59629-586-5 (alk. paper)
1. Rhode Island--History--Anecdotes. 2. Tales--Rhode Island. 3.
Folklore--Rhode Island. I. Title.

F79.5.I56 2008
974.5--dc22
2008035271

This book is dedicated to my wife, Ann-Marie, who has always supported me in everything I do.

INTRODUCTION

Rhode Island is the smallest state in the union, but it has the biggest name. It is officially known as the "State of Rhode Island and Providence Plantations," but we like to call it "Little Rhody." Rhode Island is also known as the "Ocean State," and to prove it, we put it on our license plates. Additionally, with its seaports and shoreline, the state was sometimes referred to as "Rogues Island" in the days when piracy was considered an "honorable" profession.

It doesn't take long to get anywhere once you're here, as the state is only an hour long and a half hour wide, so to speak. But we hate to travel more than ten minutes to get anywhere, lest we have to pack a lunch!

Rhode Island is a state steeped in history. Founded in 1636, we had historic sites before other states were even states. Some of the oldest stuff in the nation is found here. We have the oldest flying horse carousel, the oldest mall, the oldest veteran's monument, the oldest synagogue and the oldest continuously operating tavern, to name just a few.

Rhode Islanders have their own way of speaking. We tend to drop our *er*'s and add *a*'s. Our state shellfish is a quahog, which is a clam we put in "chowda." Our state bird is a chicken—specifically, the Rhode Island Red. Our state rock is Cumberlandite, a mineral that is only found in Rhode Island.

It is facts such as these that make this state both interesting and unique. This book is a collection of forgotten stories connected with Rhode Island. They are the kind of stories that one may not have learned about in school. Some are funny and interesting, others are just downright strange, but all of them are true. It is hoped that this book will leave the reader saying, "Hey, I never knew about that..."

HE DUG HIS OWN GRAVE

It has been said that if you want something done right, then you have to do it yourself, and Arnold Staples of Esmond wanted it done right. That's why the former undertaker, today known as a funeral director, decided at the age of eighty-nine that he should dig his own grave. This way, he could be sure everything was done to his specifications. He didn't know it then, but the grave he so carefully took the time to dig would only be temporary.

It wasn't that he had a premonition that he was going to die, but he was eighty-nine years old, and in 1911, the average life expectancy for a man was only about fifty-five years. Perhaps he figured he had already beaten the odds and took making his final arrangements to another level.

By all accounts, he was in good health that December when he and a helper went to the cemetery on Chamberlain Street in Esmond to complete the task. Why he chose to dig at a time of year when the ground was frozen is unknown, but perhaps he wanted to dig his grave on the anniversary of the death of his wife, who died December 10, 1877.

Once the job was complete, boards were placed over the hole to prevent anyone from falling in. Unfortunately, heavy spring rains later caused the sides to collapse, requiring Mr. Staples to dig the grave again. This time, measures were taken to prevent another cave-in.

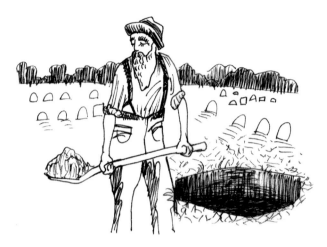

Mr. Staples lived for another eighteen months before he succumbed to old age. He died at his home on July 1, 1913, at the age of ninety. After his funeral, he was interred in the grave he had so carefully prepared for himself.

A grave is supposed to be one's final resting place, and it can be surmised that Mr. Staples expected to rest in peace until Judgment Day. But that was not to be. In 1934, relatives had the remains of Mr. Staples, his wife and their children moved from Esmond to a family plot in the Acotes Hill Cemetery in Chepachet.

A MYSTERY MAN IN MIDDLETOWN

On the evening of June 13, 1959, Albert Presso went to answer the insistent knocking on the door to his Willow

Avenue home in Middletown. He opened the door to find a well-dressed man in his twenties wearing a business suit. The man identified himself as Greg Saunders and then blurted out an incredible story about a plane, a fire, bailing out and a crash. Mr. Presso called the Middletown Police, who arrived in short order and took Saunders to Newport Hospital for examination. There he gave a detailed account of what had happened.

Saunders claimed he was a travel agent from Los Angeles, California, on a combined business and pleasure vacation. He left California a few days earlier, flying his own airplane, and after making several stops in cities across the country, he wound up at Flushing Airport in Queens, New York.

At 4:30 p.m. on the thirteenth, he took off from Flushing toward Maine and attained a cruising altitude of sixty-five hundred feet, which put him above a rainstorm moving up the coast. Somewhere near Rhode Island, he noticed flames licking out of the port engine. He tried to extinguish the fire, but couldn't. He tried calling for help, but his radio was dead. At this point, he felt he had two options: drop down through the storm and risk a crash landing, or set the autopilot, bail out and take his chances. He opted for the latter, and set the autopilot on a heading that would take the plane out over the Atlantic Ocean and away from populated areas.

Saunders explained that he normally wouldn't have a parachute aboard, but because his flight plans had carried him over water, he thought it prudent to carry one, along with an inflatable rubber raft. He said he landed on a Christmas tree farm, and after removing his parachute, he

began looking for help. After hiking for an hour, he found himself at Albert's home.

Officers were skeptical of his story. They noted his neatly pressed suit, shined shoes and the fact that no reports of any downed aircraft had been received. He had no identification, claiming his wallet had been left in the plane. When pressed, he changed the subject, stating that he needed to file a claim with the Federal Aviation Administration and his insurance company for the loss of his plane. With nothing to hold him on, the police took him to the Viking Hotel in Newport until they could verify his story.

The investigation revealed that there was no record of Saunders ever being at the Flushing Airport, and officials in Boston said he hadn't filed any flight plans with them, as required by law. Phone company records indicated that the Los Angeles address Saunders had given was fictitious. An air search at first light failed to find any trace of Saunders's abandoned parachute.

When police returned to the hotel, they discovered that Saunders had left, telling the desk clerk that he was "going back home to Boston." Boston authorities were notified to watch for Saunders, as Rhode Island officials had more questions for him, but Saunders never showed. In fact, he was never seen again.

Who was Greg Saunders, if in fact that was his real name, and what would possess him to attempt such a hoax? Was it the media attention, an attempt at insurance fraud or was it something else? The story is long forgotten, but the mystery remains.

THE STEAMER *EMPIRE STATE*

There was a time in the mid-nineteenth century when steamers were a preferred mode of transportation for those who could afford to book passage. But steamship travel was not without its perils, as evidenced by the steamer *Empire State* of the Fall River Line.

On the night of July 29, 1856, the ship left Newport, bound for New York, with passengers settled in their staterooms for the night. Just off Point Judith, an explosion occurred below deck when a steam chest burst under pressure. Frightened passengers emerged from their cabins; some, casting modesty aside, wore life jackets and not much else. The captain and crew quickly determined that the ship was not in danger of sinking and did their best to restore order.

Less than two years later, in March 1858, the *Empire State* was proceeding cautiously in thick fog along Long Island Sound when it ran aground on some rocks near Sands Point. Fortunately, no serious damage was done to the hull, and the passing steamer, *Vanderbilt*, was able to render assistance by cheerfully accepting the *Empire State*'s passengers.

The following year, on the night of March 6, 1859, the *Empire State* was involved in a collision with the schooner *Uncas* off the south end of Goat Island in Newport. The *Uncas* quickly sank in thirty feet of water; however, the crew was rescued by those aboard the *Empire State*.

One would think that three accidents in three years would brand the *Empire State* as an unlucky ship, which would be bad for business, but this does not seem to have been the case. The ship continued to prowl Narragansett Bay for another twenty-eight years with an apparently perfect safety record. The end came on May 13, 1887, when it caught fire while anchored in Bristol Harbor and sank. What remains of it lies there still, occasionally visited by scuba divers.

It Could Have Been "Coffin Corners"

The Village of Greene is located in western Coventry and is named for General Nathaniel Greene of Revolutionary War fame. But before the name Greene was chosen, the area almost became known as "Coffin Corners."

Carr's Trail, found on contemporary maps, was once called Coffin Road. In 1859, railroad tracks crossed just to the west of Coffin Road, where a railroad station and a post office were built. Under normal circumstances, naming them would have been a simple matter, but the railroad didn't think that "Coffin Corners" would be good for business, and the post office felt that "Coffin Road Depot" sounded too dismal. Therefore, the name "Greene" was selected to honor the hero, who was born in Rhode Island.

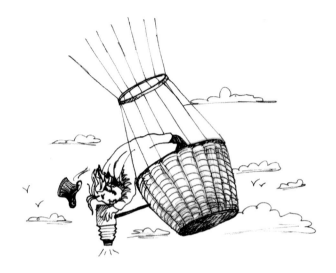

THE QUEEN OF THE AIR

On the afternoon of Saturday, June 2, 1860, a massive hot air balloon called Queen of the Air lifted off from Exchange Place in downtown Providence with two men aboard. The winds carried the craft over Fox Point and out over Narragansett Bay. After traveling twenty-two miles in forty-five minutes, it landed on the farm of John Manchester in Portsmouth, where the two aeronauts spent the night as his guests.

For those not aware, the Queen of the Air made history four months later on October 13, when it ascended twelve hundred feet over the Boston Common and a man named James W. Black took the first successful aerial photograph in the United

States. He had tried to photograph Providence from the air on an earlier date, but the pictures didn't come out.

SUSPICIOUS BEHAVIOR

Around midnight on April 16, 1859, Constable Perry and his partner of the Providence Night Watch were on patrol when they heard the sounds of digging. Being the inquisitive officers that they were, they crept toward the sound, keeping to the shadows to maintain the element of surprise.

From their vantage point, they could see two men digging a hole under a large tree. In low whispers, the officers quietly discussed what the men could be up to. Were they hiding stolen goods? Perhaps. Or maybe even worse, a body!

After waiting a reasonable amount of time, they decided to make their move. When the officers emerged from the shadows and announced their presence, the two men dropped their shovels and ran off with the bluecoats in hot pursuit. The pair was apprehended in short order and returned to the scene of the crime. There they confessed that they had been digging for gold! When pressed for further details, the duo explained that they knew gold was buried under the tree because the Bible had directed them to dig there. It was then that the officers noticed an open Bible among the tree's branches. On the ground, they found a divining rod and several "magical diagrams." The

men were released and told to leave the area. Even today, superstition can be a driving force in people's lives.

The Perils of High Fashion

In the 1850s, proper, well-dressed ladies wore hoop skirts, a fashion statement that required the wearing of a series of hoops under layers of petticoats to expand the hem of an ankle-length dress. The attire left many ladies wishing for a style change for a variety of reasons, not the least of which were incidents such as the one that occurred in East Greenwich in 1859.

On a warm afternoon in May, members of a church group boarded a steamboat for Newport. Among them was a woman wearing a wide hoop skirt. As the ship made its way out of the harbor, the woman lifted her skirt in a modest fashion and began to descend a stairway to the promenade deck. At the same time, a gentleman walking with his head down began to make his way up the same stairs. The woman couldn't see the man, as her hiked skirt blocked her view. The man, obviously distracted, continued climbing the stairs while looking down. The two met halfway on the stairs in a most embarrassing manner when the man's head became caught under the woman's hoop skirt! It would be interesting to know if they became friends afterward.

Saved By a Submarine

March 4, 1922, was either a lucky or unlucky day for the crew of the fishing schooner *Grace Clinton*, depending on one's point of view. At three o'clock that morning, the ship was chugging along in the water between Block Island and Point Judith when a fire broke out in the engine room. Ship's Engineer Elmer Fortin, of East Greenwich, tried to extinguish the flames and was badly burned in the process. Within two minutes, the entire compartment was ablaze, and it was feared that the gasoline-laden fuel tanks would explode.

The five-man crew quickly donned life jackets and prepared to abandon ship. Not another vessel was in sight, and they no doubt wondered how long they could last in the frigid thirty-five-degree water. As they stood ready to jump, a U.S. Navy submarine suddenly surfaced and came alongside their ship. The *Clinton*'s crew scrambled aboard, grateful to be saved from certain dearth. The sub then headed at full speed to New London, Connecticut, where Mr. Fortin received medical treatment for his burns.

The submarine was the *S-19*, commanded by Lieutenant Commander William J. Butler. Almost three years later, on January 13, 1925, the *S-19* ran aground off Massachusetts. This time, it was the rescuer that needed rescuing.

A NEEDLESS BATTLE

In the final hours of the war with Germany in World War II, a naval engagement took place off Point Judith that cost the lives of sixty-six men. The battle did nothing to shorten the war or change its outcome. Even worse, history shows that it never should have happened.

By May 1945, Germany was on the verge of defeat. On May 4, Admiral Karl Donitz, commander of the German navy, ordered all U-boats to cease hostilities and return to their bases. For some unknown reason, the commander of the *U-853*, operating off the Rhode Island coast, didn't obey the order and continued with his patrol.

The following day, the sub sighted the merchant ship SS *Black Point* off Point Judith. At 5:40 p.m., a torpedo struck the *Black Point*, blowing the rear portion off the ship. Thirty-four crewmen made it to the lifeboats before the ship sank, taking eleven of its crew with it. It was the last U-boat casualty of the war.

Within minutes of the sinking, several navy and U.S. Coast Guard vessels were searching for the sub. Once sonar contact was made, a series of depth charges were dropped. The sub commander tried several tricks to elude the hunters, but none of them worked. The *U-853* was finally sunk seven miles east of Block Island, in 130 feet of water, with a loss of all hands.

Germany surrendered on May 7.

Today, the sub lies virtually intact on the ocean floor, draped in fishing nets. In the years since the battle, recreational scuba divers have braved the dangerous waters to visit the wreck. Some have died while doing so, the last in 2005. Thus, the death toll related to this needless battle continues to rise.

THE SUICIDE BRIDGE

On Farnum Pike in Smithfield, there is a bridge that spans the Woonasquatucket River connecting the villages of Georgiaville and Esmond. It's a modern-looking bridge that hundreds of people cross every day, never realizing that it replaced an earlier one referred to as "the Suicide Bridge."

The actual Suicide Bridge was a large, imposing, wrought-iron structure, anchored by massive stonework on either side of the river. It was obviously built to last for a hundred years, yet its tenure was relatively brief. It earned its name from the suicides and other deaths that occurred there over a span of twenty years. The name of the bridge was so commonly accepted that it was even referred to as such in old town death records and newspaper articles.

As near as can be determined, the first suicide occurred at the bridge in 1914, when a desperate woman leapt into the water. Several others followed suit in the next few years. In addition to the suicides, there were also accidental drownings of swimmers who dove from the bridge.

Naturally, stories about the bridge began to circulate. Some said it was cursed or somehow had a demonic force connected to it. Young boys told ghost stories about the bridge being haunted by the tormented souls of those who had died there. Whether or not one believes in such things, there were those who avoided the bridge at night.

Things were uneventful at the bridge for most of the 1920s, no doubt leading some to believe that the curse, if in fact there was one, had been lifted. But in 1932, bad luck returned. In January of that year, a car with two men inside crashed through the guardrail and plunged into the water. One man escaped, but the other drowned.

The last recorded death to occur at the bridge happened on February 20, 1933, when a man was hit by a car and killed. He was the twelfth person to die at the bridge in a span of twenty years.

The Suicide Bridge was dismantled in 1934, and a new bridge was constructed in its place. Since then, there have been no reported suicides from the bridge.

A Fatal Ride

On the evening of February 3, 1859, a train belonging to the Boston & Providence Railroad pulled into Providence, where the conductor was notified of something dripping down the sides of one of the passenger cars. Upon checking, he discovered that the "something" was blood, and there seemed to be quite a bit of it. Investigation revealed that

when the train left Attleboro, Massachusetts, a sixteen-year-old youth had climbed onto the roof in order to get a free ride back to Providence, where he lived with his stepfather. At one point during the trip, the youth apparently stood up and forgot to duck when the train passed under a bridge.

A BOAT ATTACK ON NARRAGANSETT BAY

August 9, 1921, was supposed to be a pleasant day of boating for five people who ventured out on Narragansett Bay, but it turned into a day of terror when they were attacked, without warning, by an airplane spraying machine-gun fire.

The bullets spat up small geysers as they trailed across the water's surface toward the boat and punched holes in the wooden hull. The frightened passengers had no idea why they had been singled out for an attack. Four were unhurt, but the fifth, a twenty-one-year-old woman from Warwick, had been shot in both legs.

The plane disappeared just as quickly as it came. As for a description, all the victims could tell the authorities was that it had the number ninety-two painted on the side.

An investigation revealed that it was a U.S. naval aircraft assigned to a destroyer fleet conducting maneuvers off Newport. The plane's crew stated that they had been having trouble with the machine gun, and its discharge had been accidental. However, Navy Admiral Ashley H. Robertson blamed the incident on "blamed stupidity," adding that the plane was not supposed to be flying over the bay in the first place.

A THUNDERBOLT STRIKES IN SCITUATE

June 17, 1943, was a beautiful day for flying. The sun was shining, and visibility was unlimited as a formation of four P-47 Thunderbolts cruised leisurely across the skies of Scituate. The planes were on a training flight that had left Hillsgrove Airport in Warwick. First Lieutenant A.A. Marston was leading the flight, followed by Lieutenants J.T. Brown, O.J. Foster and R.W. Powell.

Without warning, one of the pilots began to experience a problem with his airplane when the engine began to sputter and lose power. The pilot radioed the others to inform them of his predicament as he dropped out of formation. Suddenly realizing that the problem might be with the fuel flow to the engine, he switched to an auxiliary gas tank, but by that time, the engine had stopped completely and wouldn't restart. He was too low to consider bailing out, and it was obvious that he was going to have to make an emergency landing.

As his plane dropped below one thousand feet, he saw an open field and aimed for it. With landing flaps down and wheels up, the Thunderbolt crash-landed, ploughed its way through the grassy field and skidded across Darby Road, where it came to rest against a stone wall.

The young pilot scrambled out of the cockpit, relatively unhurt. Once it was apparent that there was no danger of fire, he surveyed the damage and no doubt wondered where he was.

The crash landing was witnessed by two volunteer airplane spotters manning an observation tower in North Scituate. They quickly notified authorities, and within minutes, army officials, the state police and two Red Cross ambulances were racing to the scene.

The pilot had caused more of a commotion than he realized. An interesting footnote to this story concerns the immediate area in which the plane went down. Few people know today that the old Suddard Farm on Darby Road was the site of one of the best-kept secrets of World War II. Its

location was a geographical anomaly, where radio signals from all over the world could be received with perfect clarity. The work there focused on intercepting enemy radio signals.

Those who worked there were credited with saving the *Queen Mary* from being sunk with ten thousand troops aboard and for stopping Japanese attempts to drop bombs on American soil using hot air balloons. Therefore, it is understandable that the crash of a military aircraft practically in the backyard of the top-secret installation created quite a stir.

After the war, the farm was considered as a potential site of the headquarters of the newly formed United Nations before the present New York City site was chosen. Due to its historical significance, attempts have been made to have the old farm placed on the National Register of Historic Places, but for various reasons, none has been successful.

THE GRAVE OF DOCTOR CARPENTER

Small, family-plot cemeteries, dating to the eighteenth and nineteenth centuries, are a common sight in Rhode Island, but the Carpenter Cemetery on Moosup Valley Road in Foster is unique, for it contains a plot bounded by four massive granite slabs, each twelve feet long, six feet high and eight inches thick. There is no gate, and the plot only has two graves, one belonging to Dr. Thomas O.H. Carpenter and the other to his young wife, Henrietta.

The story attached to this oddity is an interesting one. Dr. Carpenter was a successful and wealthy physician who practiced in Foster in the early 1800s. His first wife divorced him after several years, but he was married again, at the age of fifty, to a young woman named Henrietta Henry, who was only nineteen. Unfortunately, Henrietta got sick and died a year later, in 1827. Dr. Carpenter married a third time, but that union also ended in divorce.

After Henrietta's death, the doctor commissioned a local quarry to cut the massive stones that surround his grave. It is said that ten yoke of oxen were required to deliver the stones to the cemetery and set them in place. A local blacksmith made the angle irons that still hold the corners together.

Dr. Carpenter enjoyed being married, but both divorces had been less than amicable. Therefore, as one legend claims, he sought to exclude his ex-wives from his existence in the afterlife by building the unusual burial plot. However, longtime residents of Moosup Valley tell of a second reason: Dr. Carpenter had the plot walled-in to keep young Henrietta from leaving him should she ever rise from the grave.

It was said that Dr. Carpenter enjoyed a good time at parties and had a friendly disposition. When he died in 1839, he was buried in his best "party suit" and dancing shoes. He left explicit instructions that his gold wedding ring be put on his finger and his watch be wound and placed in his pocket.

IT CAME FROM OUTER SPACE

On the night of August 27, 1913, an electrical storm was pelting Tiverton, when suddenly, from out of the sky, a meteor came streaking down and landed in the Sakonnet River. Witnesses described the blazing orb as one of unusual size, which begs the question: how many others had they seen? When it struck the river, it detonated in a terrific explosion that sent a huge plume of water shooting skyward, followed by the sound of hissing steam. The roar of the blast was said to have been heard for twenty miles in all directions, and the concussion was blamed for breaking nearby windows, rattling crockery and even jarring a merry-go-round into motion. One house caught fire and burned, and the cause was said to be a fragment of the meteor. Fortunately, no injuries were reported.

THE PHANTOM AIRSHIPS OF 1909

With the approach of Christmas in 1909, many people in southern New England began to see strange lights in the night sky. It was universally agreed that the lights were not Biblical, but man-made, yet this knowledge only added to the mystery, for the lights were said to be attached to a large aircraft. The question was: whose aircraft was it, and more importantly, who was flying it?

The sightings began soon after Wallace E. Tillinghast, a Worcester, Massachusetts business owner, announced that he had invented an airship that was technologically more advanced than any known aircraft of the day. The body of the ship was said to resemble the cigar shape of a Zeppelin, but with airplane wings jutting out thirty-six feet from either side, thus making it a combination of a balloon and an airplane. The craft was said to be powered by a 120 horsepower gasoline engine of secret design.

Tillinghast told reporters in early December that, on September 8, he had flown his invention on a six-hundred-mile round trip from Worcester to New York City and back, during which he claimed the airship had averaged 120 miles per hour and attained an altitude of four thousand feet. This was truly remarkable for that era, for if true, not only had Mr. Tillinghast invented the most advanced aircraft in the world to date, but also, in one flight, he had single-handedly broken every standing aviation record of the day.

However, some became suspicious of the fact that Mr. Tillinghast refused to let anyone actually see his invention. Yet, even without confirmation of his remarkable claims, many newspapers across the region ran the story anyway. It was shortly afterward that many people began to "see" Tillinghast's flying machine passing overhead in the night sky. The first sightings were in the Boston and Worcester area, but within a few days, many reputable Rhode Islanders were seeing airships, too.

On December 23, it was reported that many citizens of Worcester and vicinity had witnessed a large aircraft

circling overhead in the night sky for about fifteen minutes. Those who saw it said that it had a powerful searchlight that sent out "brilliant rays of light before it."

Many assumed the aerial sight was Mr. Tillinghast flying his airship, and Tillinghast himself did nothing to discourage this line of thinking. When asked for comments by reporters, he simply declined to talk to them. This odd behavior from someone who stood to make millions from his invention caused some reporters to attempt to prove it was all a hoax.

At one point, a *United Press* reporter thought he had tracked the airship to its secret location, but he was arrested for trespassing before he could confirm his suspicions. In response to this, Tillinghast announced that he would exhibit his airship at an aero show in Boston in February. In the meantime, airship sightings continued throughout southern New England, from Willimantic, Connecticut, to Boston and everywhere in between.

On December 27, citizens of West Warwick reported seeing a mysterious light in the sky that they believed was Tillinghast and his airship. On February 5, 1910, a strange light was reported moving southward over Woonsocket. Word was sent to Providence to watch for it, but nobody from that city reported seeing anything unusual, leaving many to wonder if anything had been seen at all.

Apparently "airship fever" had taken hold, and advertisers were quick to capitalize on the phenomenon.

Locally, one brewery began running ads in newspapers that depicted an airship with a man (presumably Tillinghast) at the controls.

When the aero show in Boston opened on February 16, Mr. Tillinghast and his invention were nowhere to be seen, thus proving once and for all that it had all been an elaborate hoax. But one question still remained: if it wasn't Mr. Tillinghast's airship, what had so many southern New Englanders actually witnessed? Several explanations have been put forth, but none of them is completely satisfactory.

Some speculated that Tillinghast simply attached lights to a regular hot air balloon. This could account for some sightings, but certainly not all of them. The unpaved roads and highways in 1909 would have made it impossible to travel quickly from one place to another hauling a large balloon unnoticed. This theory assumes that Mr. Tillinghast owned a balloon in the first place, and there are no known records to indicate that he did.

Some wondered if it was a military airship, but historical records indicate that this is unlikely. Although the army used balloons as early as the Civil War, and owned several large balloons in 1909, there were no army balloon-training grounds located in New England. The U.S. Navy didn't begin its airship program until 1913.

Some put forth the catch-all explanation of "mass hysteria," meaning that many people were simply conjuring up airships in their minds. But this, too, seems unlikely.

It is interesting to note that, earlier that same year, phantom airships were observed over England. Perhaps it was these sightings that gave Mr. Tillinghast the idea for his hoax. But if it wasn't Mr. Tillinghast flying his "invention," what did people see in the Christmas skies of 1909?

A Train Wreck at Valley Falls

A horrible accident took place in Valley Falls on August 12, 1853, when one train slammed into another, killing twelve persons. The accident occurred on a sharp bend above Mill Street as one train was making its way north, away from Pawtucket, and another was traveling south. The northbound train had waited for two minutes at its last stop, as required by the railroad time schedules. This delay was necessary to clear trains off the tracks farther up the line. However, the second train was running late, and the engineer was trying to make up for lost time by running full throttle at forty miles per hour. The two trains met head-

on in a devastating collision. The impact telescoped the cars into each other, crushing and maiming the passengers. The accident was blamed on a two-minute time difference between the watches of the engineers of each train.

An interesting footnote to this tragedy is that this wreck was photographed by Mr. L. Wright of Pawtucket. His photographs of the scene are the earliest-known images of a train wreck.

HE SURVIVED THE *METIS* DISASTER

The following story is one of survival and irony. On the night of August 30, 1872, the steamship *Metis* collided with the schooner *Nettie Cushing* off Watch Hill. Both ships sank, and sixty-seven souls were lost, but eighty-five survived. Among the survivors was a sixteen-year-old named Frederick Kendricks, who had been sailing aboard the *Metis* with his father.

Less than one year later, young Frederick was enjoying a warm June afternoon with some friends at Georgiaville Pond in Smithfield, when he slipped and fell into the water. The water was over his head, and he drowned before his friends could reach him.

A HISTORIC BRIDGE IN CHEPACHET

An unusual incident occurred in the Village of Chepachet on May 24, 1826, that involved the murder of an elephant.

The pachyderm belonged to a man named Titus, who made his living by traveling the countryside giving exhibitions that delighted old and young alike. The elephant's name was Betty, or "Big Bess," and she stood over seven feet tall. During the exhibition in Chepachet, Mr. Titus commented on the toughness of Betty's hide and remarked how even a musket ball couldn't penetrate it.

Accounts of what happened next vary by source, but the gist of the story is this: That evening, as Mr. Titus and Betty were crossing the bridge that spans the Chepachet River, some gunshots rang out from the direction of a nearby mill. Some of the pellets hit the elephant with little effect, but one shot struck Betty in the eye and killed her.

Those responsible were ordered to pay Mr. Titus $1,500, but this was hardly enough as Titus had lost his means to make a living.

For many years afterward, the bridge where the incident happened was often referred to as the "Elephant Bridge." The original bridge was washed away in a flood in 1867, and subsequent ones have replaced it.

In more recent times, the bridge was dedicated as the "Lt. William G. Schanck Jr. Memorial Bridge." Lieutenant Schanck was born in 1948 and raised in Chepachet. During the Vietnam War, he was commissioned a second lieutenant in the United States Marine Corps and assigned to the First Recon Battalion of the First Marine Division. He was killed on June 21, 1969, when the helicopter he was in was shot down twenty-two miles from Da Nang.

The Wreck of the *Rhode Island*

There have been numerous ships lost in Rhode Island waters, but only one with the name of *Rhode Island*. The *Rhode Island* was a 340-foot-long, side-wheel passenger steamer owned by the Stonington Steamship Company. It sank on November 11, 1880, while operating in thick fog off Bonnet Point. Visibility that night was said to be zero. As the captain was edging the ship through the western passage of Narragansett Bay, the craft ran aground on some rocks. Once on the rocks, heavy waves began bashing it to pieces. Fortunately, there was no loss of life, and most of the cargo was saved.

This was not the first disaster for the *Rhode Island*. Several months earlier, on April 17, 1880, it was traveling in Long Island Sound in heavy fog when it was involved in a collision with a three-masted schooner. The bow of the schooner tore away a section of railing and smashed the port paddle box, causing heavy damage. The *Rhode Island* dropped anchor and awaited rescue, but the schooner, although damaged, fled the scene. Its identity was never established.

The Second *Rhode Island*

After the *Rhode Island* was lost, a second steamer bearing the same name, owned by the same company, was launched

in May 1882. Its luck was no better than its predecessor's. Less than two months after launching, it was involved in a collision on Long Island Sound. Though heavily damaged, it managed to stay afloat until another steamship came alongside and towed it to New York for repairs. The ship that came to the rescue of the crippled *Rhode Island* was, ironically, the SS *Providence* of the Fall River Line.

This was not the only bad luck to visit the new *Rhode Island*. In 1884, a man was crushed to death when he fell beneath the paddlewheel. In 1888, it ran aground near Stonington. In 1894, two men were arrested for discharging pistols in a stateroom. It was involved in other collisions in 1898 and 1899, and in 1902, a man committed suicide aboard. Another collision in 1907 caused considerable damage to the structure of the ship. In 1913, it ended its sordid career when it was sold as "junk" to a Connecticut dealer.

THE DARKEST DAY

May 19, 1780, is known as New England's "darkest day"; a day when the sun was blotted out and the day became like night. The day was so dark that people had to light candles to find their way about.

Many of the frightened populace wondered if Judgment Day had come. They cited "omens" of the previous several days, when the sun had hung in the sky a blood red color, and the sky itself appeared a sulfurous yellow. Soot was

seen collecting in rivers and rain barrels. Then the darkness descended.

No doubt everyone breathed a collective sigh of relief when, after twenty-four hours, the skies began to clear and returned to the normal shade of blue. The best minds of the day were at a loss to explain the "supernatural" phenomenon. Modern scientific minds believe the darkness may have been caused by forest fires in the West as the smoke from those fires was carried by the jet stream over New England. But that is only a theory.

A NAVY SUBMARINE IS RAMMED

One forgotten story of Rhode Island occurred on the night of September 25, 1925, when the steamer *City of Rome* was making its way from New York to Boston. It was just east of Block Island when the captain saw a single white light ahead, resting low on the water. The 1920s was the era of Prohibition, and it was assumed that the light belonged to a rumrunner—an outlaw who ran liquor ashore in small boats from offshore ships during the night. Surely, the captain thought, the boat would see the brightly lit steamer and stay away. As a precaution, the captain altered his course to steer clear of the light; however, it soon became apparent that the rumrunner was going to cut across the ship's bow. A warning was sounded, and evasive action was taken, but it was too late.

The "rumrunner" turned out to be the U.S. Navy submarine *S-51*. The *City of Rome* plowed into it, striking just forward of the conning tower, and sent it to the bottom with thirty-three crewmen still aboard. Only three seamen managed to escape from the stricken sub just before it slipped below the surface.

Navy divers arrived the following morning, but in those days there were few options for rescuing crewmen trapped below the surface in a submarine. Those trapped in the sub suffocated when their air supply gave out within seventy-two hours. A year later, the wreck of the *S-51* was raised and towed to Brooklyn, New York. Blame for the accident was placed on both ships.

If there was to be one positive note to this incident, it was that this sinking was used as a case study by the navy to develop ways to rescue future submariners trapped below the surface. The knowledge learned was useful in saving crewmen trapped aboard the USS *Squalus* when it sank off the coast of Portsmouth, New Hampshire, in 1939.

BORN ON THE RAILROAD

On September 6, 1859, Mrs. Peter Sidebottom and her young daughter boarded a train in Boston that was going to Providence. During the trip, Mrs. Sidebottom went into labor. The train, with its schedule to keep, continued toward Providence, while two passengers, Benjamin and Julia B. Nickerson, ministered to the woman as best they could.

Just before the train arrived in Providence, Conductor Ira Gliddon learned that he had two additional passengers—twins—a boy and a girl.

The boy was named Benjamin Gliddon Sidebottom, and the girl, Julia Bacon Sidebottom.

A Nuclear Accident

Few people today are aware that Rhode Island had a nuclear radiation accident in the Village of Wood River Junction, located in Richmond. The incident occurred on July 24, 1964, at a facility that specialized in recovering uranium from scrap reactor material. On that day, a worker was standing over a cleaning tank and accidentally mixed the wrong solution. The result was a fatal dose of radiation poisoning. Cleanup crews that responded were also exposed to radiation, but all recovered.

The Hopkins Hill Bomber Crash

During World War II, many servicemen died while protecting our nation; some while overseas, and others while protecting the homefront. One tragic event on the homefront occurred in West Greenwich on April 3, 1942, when a U.S. Army B-25 Mitchell bomber crashed on Hopkins Hill and all aboard were killed.

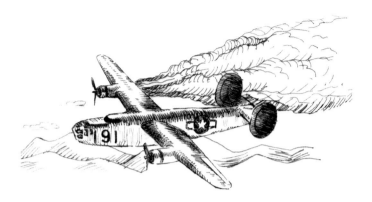

The B-25 Mitchell was a versatile twin-engine bomber used by the army early in the war for coastal patrol. The Mitchell became famous when Colonel James H. Doolittle led a flight of sixteen aircraft off the USS *Hornet* in the first Allied attack on Japan.

The morning of April 3 promised to be a pleasant day for flying. About 5:30 a.m., a B-25, piloted by Lieutenant George Loris Dover, of Shelby, North Carolina, took off for antisubmarine patrol from Westover, Massachusetts. Also aboard were Lieutenant Neil Frame, Sergeant Robert Trammell, Private Robert Meredith and Private Thomas Rush.

As the plane with its crew headed south over Rhode Island, one of the engines started to sputter and lose power. Lieutenant Dover was an experienced pilot and evidently didn't deem the situation serious because no distress call was ever received, and no order for the crew to bail out was issued. It is believed the pilot was

changing course to head toward Hillsgrove when the aircraft completely lost power and fell from the sky.

The bomber crashed on Hopkins Hill and burst into flames. Shortly afterward, as the flames spread to the bombs, there was a thunderous explosion that shook the ground like an earthquake.

The army came and removed all debris from the site. Today, time and Mother Nature have erased all traces of the disaster, and the incident is all but forgotten.

Lieutenant Dover was only twenty-five years old at the time of his death, and his loss was not the only one suffered by the Dover family during the war. At his funeral, George's younger brother, Grady, was quoted by the *Shelby Daily Star* as saying, "Somebody'll have to take Loris's place." Grady enlisted in the Army Air Corps as a pilot and was later promoted to first lieutenant. He was killed in action when his B-17 bomber went down during a raid over Germany on February 10, 1944.

THOUGHTFUL BANK ROBBERS

In April 1868, three men went to the home of the cashier of the Scituate National Bank and produced guns. Under threat of death to himself and his family, they escorted the cashier to the bank, which was closed at the time. Once there, they tied him up and asked how much money was in the bank, to which the man replied, "Not much."

The robbers made a search of the bank and found $8,000 in bills marked "Citizens Union Bank." Unbeknownst to them at the time, this money would be worthless to them as it could not be redeemed anywhere except at the bank from which they took it. They also found another $9,000 in legal tender in the vault. Next, they cleaned out the safety deposit boxes, which contained the valuables of bank customers.

Realizing their total take was just under $17,000 dollars, one of the robbers commented to the cashier that if they had known they would be getting less than $50,000, they wouldn't have bothered. The robbers then escaped to parts unknown.

Normally that would have been the end of the story, but one week later a package arrived at the bank by express mail with a Philadelphia postmark on it. Inside were all of the important papers, documents, wills and other personal items that had been in the bank customers' safety deposit boxes.

STRANGE CIRCUMSTANCES

There is a special bond between a mother and a child. A case in point involved Sergeant Decatur M. Boyden, of the Seventh Rhode Island Regiment, who in April 1864, during the Civil War, was wounded by shellfire in battle in Virginia. On that day, his mother was entering the kitchen of her Woonsocket home when she suddenly heard her son's voice cry, "Oh, Mother!" She looked around, fully

expecting to see him standing there, but to her surprise, she found nothing.

She related the strange incident to other members of the family, saying she was convinced that Decatur had been killed or wounded. To her shock, two others related that they had dreamed of Decatur being severely wounded the night before.

A point of fact: though Sergeant Boyden was wounded about the same time his family had their premonitions, he did survive the war and lived to a ripe old age.

DUELING IN RHODE ISLAND

Dueling was a formalized style of one-to-one combat between two individuals, usually men, traditionally with swords or pistols. History records several duels fought in Rhode Island, and ironically, none of them involved Rhode Islanders.

The first two recorded duels in Rhode Island were fought in Providence, and each involved Massachusetts men, the first in 1806, the second in 1827. The second ended with one man shot in the leg.

The next took place in Cumberland in 1832 at a place still known today as Duel Hollow, located about a mile north of Cumberland Hill. In this duel, one participant accidentally shot himself in the leg.

The fourth duel occurred in 1843 on the Moses Brown Farm in Providence between a Boston man and another from North Carolina. It ended with one man slightly wounded.

Another duel was fought at Scott's Pond in Lincoln in 1835 and is said to have ended with both participants being wounded.

Perhaps the main reason these duels were fought in Rhode Island is because neighboring states had stricter dueling laws at the time. It wasn't until 1838 that Rhode Island classified dueling as murder, and the penalty for dueling was death. In addition, strict penalties were enacted for even challenging one to a duel. As time went on, dueling fell out of fashion. Besides being illegal, it was dangerous, and it is today all but forgotten.

THE ADAMSVILLE CHICKEN MONUMENT

Adamsville is a village in Little Compton and is home to the only monument in the United States dedicated to a chicken—specifically, the Rhode Island Red. The monument was erected in 1925 by the Rhode Island Red Club of America on land donated by Debbie Manchester.

The Rhode Island Red is a breed of chicken that was developed in Little Compton around 1900. Today, they are prized as show birds, as well as for their meat and eggs. The Rhode Island Red is also the official state bird of Rhode Island.

The monument is on the National Register of Historic Places.

WAS IT WORTH IT?

Counterfeiting money in colonial Rhode Island wasn't especially difficult considering the many forms of currency then in circulation, but if one were caught, the penalties could be severe. Take, for example, the case of a Cumberland man, who was convicted in Providence Superior Court of passing counterfeit money in several communities. The judge sentenced him in full accordance with the law of that era. On October 10, 1755, he was forced to stand in the stocks for eight hours, have his ears cropped and be branded with a hot iron.

SABRES CLASH OVER CUMBERLAND

Perhaps the most famous American jet fighter of the Korean War was the North American F-86 Sabre. It was considered "state of the art" for its day, capable of serving as both a fighter-interceptor and dive bomber in all sorts of weather, and it was the first swept-wing jet fighter used by the U.S. Air Force.

Flying such a high-tech piece of equipment required skill and training, but even the training could be dangerous. A case in point happened when two Sabres collided

in a training accident twenty-five thousand feet over Cumberland on June 13, 1951.

The two jets were part of a team of four practicing attack and evasion procedures when the accident happened. Both aircrafts were heavily damaged in the collision, but fortunately the pilots, Lieutenants Leo R. Kirby Jr. and Michael A. Corba, managed to eject and parachute to safety.

Both aircraft had been going over five hundred miles per hour at the time of the crash, and the fact that both pilots escaped was a miracle. As they hung in the air from their chutes, the debris from their aircraft began crashing to the ground in the area of Abbott Run Valley Road.

Lieutenant Kirby's plane crashed in a field three hundred feet from a home and exploded into a huge fireball. The blast hurled a portion of the engine several hundred feet before it came down next to the Cumberland Grange hall. As the wreckage burned, .50-caliber bullets from the aircraft's gun magazines began going off, sending live rounds whizzing through the air and forcing bystanders to dive for cover.

The pieces of Lieutenant Corba's jet came down in various yards of the houses along Abbott Run Valley Road. One portion fell into a backyard, where a woman was washing windows. When she went to examine the debris, flames set the gun magazines off, sending her running into her house.

Both pilots were treated at nearby hospitals and recovered from their injuries. The replacement cost of an F-86 jet aircraft at the time was $185,105.

The reader may be interested to know that this was not the first aviation accident to occur on Abbott Run Valley Road. On June 14, 1943, a U.S. Army P-47 Thunderbolt crash-landed in the middle of the road after clipping several treetops and a telephone pole. The plane was demolished, but the pilot, Lieutenant William King of the 326th Fighter Group, walked away with only minor injuries.

FOSTER'S COVERED BRIDGE

Rhode Island's only covered bridge on a public road spans Hemlock Brook in Foster. The bridge looks every bit like the nineteenth-century covered bridges found elsewhere in New England, but this one only dates to 1994. There is a sad story connected to the bridge; one that involves a crime, redemption and loss.

The idea to construct the covered bridge was put forth by a Foster resident who had harbored a fascination with them since childhood. The last covered bridge in Rhode Island had been torn down in 1920, leaving "Little Rhody" the only New England state without one.

Once the idea was accepted, it took six years to raise the funds through private and corporate donations. The labor was provided by local volunteers, who felt it was a privilege to be part of such a project.

The bridge was dedicated in December 1992, much to the delight of many Rhode Islanders, who made it a point to go see it. But less than a year later, the bridge was burned

by arsonists. Almost immediately, fundraising efforts began to rebuild the structure.

A reward of $5,000 was posted, and it wasn't long before three suspects were in custody. All three men were convicted and given sentences that included community service. One of them, a nineteen-year-old from Glocester, possessed some carpentry skills and offered to help rebuild the bridge, but his offer was flatly refused. Instead, he completed his sentence by doing chores at the Foster police station. It is said that he went beyond what was required of him by constructing a much-needed juvenile detention room. When he completed his community service hours, Foster's police officers felt that the young man was truly sorry for his deed and had turned himself around.

Unfortunately, the young man was killed in a car accident in Glocester in 1995. The following year, the detention room at the Foster police station was dedicated to his memory.

The bridge was rebuilt and rededicated on November 5, 1994. Since then, the bridge has become a recognizable symbol of Foster. It even adorns the official uniform patch worn by Foster's police officers.

The Legend of the Carbuncles

Carbuncle Pond and Carbuncle Hill are located in western Coventry on either side of Route 14. They derive their curious names from a forgotten legend of a giant snake that had a large, glowing red gem, or carbuncle, embedded

in the center of its forehead. The fearsome creature was said to live on Carbuncle Hill long before the arrival of the first European settlers to the area. At night, when the creature left its lair in search of food, the bright glow from the carbuncle could be seen moving through the dense woods by hunting parties on nearby hills.

Over the years, many young men tried to capture the creature to obtain the gem, but it was said that the snake knew when danger was nearby because the gem would change from red to green and thus alert it to hide or move away. Then, one day, a group of youths managed to take the snake by surprise and set upon it. The snake fought back by thrashing its tail with such force that trees were toppled and rocks split in half. Some of the split rocks from this battle are said to be visible today. But despite its efforts, the creature was finally killed, and the gem was brought back to the tribe.

The gem maintained its ruby-red glow and was used to illuminate tribal council meetings. Whenever the tribe was in danger of attack by enemies who wanted the carbuncle for themselves, the color would change to green, thereby giving warriors time to prepare. Thus, the tribe defended the stone for generations.

When white men came to the area, they learned of the carbuncle and made attempts to take it. This culminated in a huge battle near Carbuncle Pond, where many on both sides were killed. At the end of the battle, the chief sachem was left standing alone with the carbuncle in his hands. Seeing that all was lost, he threw the gemstone into Carbuncle Pond.

The white men tried for years to recover the carbuncle, but they could never locate it. It was said that spirits were hiding it from their eyes, waiting for the day the tribe would return.

Some say the story is just a folk tale made up by some colonial storyteller as there is no historical evidence to support it. Others claim that it is real. Either way, that's how the hill and the pond are said to have received their names.

REQUIEM FOR AN ELEPHANT

The Slater Park Zoo was once located in Slater Park in Pawtucket. One of the main attractions was an elephant named Fanny, which was acquired by the zoo from the Ringling Brothers Barnum & Bailey Circus in 1958. When she arrived in Pawtucket, she was initially kept at the park's boathouse, but was later moved to an unused fire station on Prospect Street. In 1984, she was moved to a new building at the Slater Park Zoo.

For almost thirty-five years, Fanny delighted kids of all ages, but she lived in less than ideal conditions. Thanks to some concerned citizens, in 1993 she was transferred to the

Black Beauty Ranch in Murchison, Texas, where she was allowed to roam free and live out the rest of her life with other elephants. She died in 2003 at the age of fifty-nine. But that isn't the end of this story.

When word of Fanny's death reached Pawtucket, a fundraising drive for a suitable memorial was begun. In 2007, a local sculptor, Chris Kane, unveiled a life-size fiberglass statue of Fanny in Slater Park. The work of art depicts Fanny holding an apple, a favorite food of hers. Those old enough to remember the real Fanny say it is a fine likeness.

THE DAY THE EARTH SHOOK

In the early morning hours of November 18, 1755, Rhode Island, as well as the rest of southern New England, was rocked by a tremendous earthquake, the likes of which hadn't been seen before and have not been seen since. Chimneys from Providence to Boston came crashing down. Buildings swayed. The ground lifted and fell. Church windows shattered, and crockery fell from cupboards.

The duration of the quake lasted for almost three minutes, and many were convinced that something biblical was occurring. As the sun rose, the destruction of populated areas was evident. Young and old alike filled local churches—at least those churches that were left standing—to pray for the Lord's deliverance.

A Strange Occurrence

A strange incident occurred in the Norwood section of Warwick that seems to defy explanation. On March 30, 1909, the body of a Catholic priest was found on the floor of the small chapel connected to his home. The body was nearly burned to a crisp, yet there was no damage to the chapel or the surrounding area.

Authorities speculated that the death was accidental, most likely caused by spillage from an oil lamp the priest had been carrying. Why the chapel hadn't been destroyed by fire was never explained.

A Fateful Meeting in Newport

On the afternoon of October 7, 1916, a German submarine suddenly surfaced in Newport Harbor and dropped anchor. At that point in time, World War I was raging in Europe, but the United States hadn't entered the hostilities yet and was attempting to remain neutral.

The sub was the *U-53*, and its appearance certainly caused anxiety among the populace. It was 213 feet long and had two large deck guns mounted on either side of the conning tower.

A small boat was launched from the sub, and several crewmen, including the captain, came ashore. The sub's commander explained to U.S. Navy officials that he was there

to deliver a diplomatic letter to the German ambassador. One of those officials was Commander David W. Bagley, who was the skipper of the destroyer USS *Drayton*. Although the sub's sudden appearance in American waters no doubt caused some consternation among the Americans, the visitors were treated in a courteous and respectful manner.

The submarine left a few hours later, headed for the open sea. It reappeared again on the afternoon of the eighth, just south of Nantucket, where it stopped an American freighter flying the United States' flag. After making sure the ship belonged to the United States, the sub commander allowed it to proceed. However, within the next few hours, the *U-53* sank five other ships in the area. (None of the torpedoed ships was of United States registry.)

After the second sinking, American destroyers were dispatched from Newport to assist in rescue operations, but they took no hostile action. The *U-53* quietly slipped away and returned to Germany. Many of the survivors of the sunken ships were brought back to Newport.

Fourteen months later, after the United States had entered the war, the *U-53* torpedoed the destroyer *Jacob Jones* off the coast of England, sending it to the bottom with sixty-four crewmen. Among the thirty-eight survivors was Commander Bagley, who had taken command of the *Jacob Jones* in May 1917. The U-boat commander, peering through his periscope, suddenly recognized Bagley in a lifeboat from their meeting in Newport in 1916.

Submarine commanders didn't generally radio the location of a sinking, for it could be detrimental to

the safety of the boat, but in this instance, the U-boat commander broke protocol and sent a distress message so that the survivors could be rescued. This act of chivalry undoubtedly saved the lives of those Americans.

Commander Bagley survived the ordeal and later went on to serve in World War II. He retired in 1947 as an admiral, after serving forty-two years in the navy.

STILL OUT THERE

In 1854, three wild circus animals escaped from their cages while being transported on the Stonington Railroad. The animals were a bear, a tiger and a panther. The bear was shot and killed a short time after, but the other two animals remained at large.

Two years later, on the night of November 18, 1856, a Coventry man went hunting with his dog and his trusty double-barrel shotgun. It wasn't long before the dog was attracted to something in the brush. Thinking it was a rabbit or a raccoon, the man moved in for the kill. As he prepared to fire, a large animal suddenly sprang toward him. The man stepped back and fired, and the blast of both barrels caught the thing in mid-leap. When it dropped to the ground, the dog immediately pounced on it, but the animal put up a fierce fight. The poor canine was forced to retreat as the animal darted into the shadows.

The hunter returned to his home, reloaded with lead-ball ammunition and resumed the hunt, this time taking his

brother-in-law along with him. They tracked the animal into the underbrush and soon discovered that, although wounded, it still had plenty of fight left. As the cornered animal prepared to fight, both men fired their weapons and killed it.

They brought the animal into town, where it was identified as a panther, measuring seven feet in length from head to tail. Its coloration proved that it was not native to New England and was most likely the one that had escaped from the circus train.

The incident, no doubt, caused some area residents to wonder what became of the tiger.

THE OFT-WRECKED MARINER

In September 1878, a weather-beaten man attired in seafaring garb entered the customs office in Providence to report that his ship had been sunk by a mysterious side-wheel steamer. He identified himself as Captain Robinson, though it is unknown if that was his real name, and he claimed to be the master of the schooner *Hattie E. Lee*. In his official report, he stated that a few days earlier, his ship had been rammed by an unidentified steamer off Cape Cod. After the collision, the steamer disappeared and failed to render aid. Fortunately, Robinson and his crew escaped in the lifeboat just before the ship went to the bottom.

Collisions at sea weren't uncommon in those days, so there was no reason for officials to doubt the man's story. A copy of the official report was sent to the U.S. Life-Saving

Service in Washington, D.C., for further investigation. It was then learned that there was no registration record of any ship named the *Hattie E. Lee*.

This revelation certainly raised questions, but any action taken is not recorded. Perhaps it was assumed to be a clerical or record-keeping error.

However, two years later, a man identifying himself as Robinson entered the customs office in Bridgeport, New Jersey, with the same story. His description matched that of the man who appeared in Providence, and he even used the same name for his ship.

Two years after that, the scene repeated itself again in Virginia, only this time he took the trouble to change the name of his vessel.

It was speculated by authorities that he was committing insurance fraud and living off the proceeds. An alert was posted at all customs houses along the eastern seaboard to watch for the man.

THE POLICEMAN WHO ARRESTED HIMSELF

It is highly unusual in a city like Newport for a police officer to suddenly be promoted to the rank of chief of police without having served in the lower ranks of sergeant, lieutenant and captain. Yet that is exactly what happened in May 1905, when Patrolman James R. Crowley became Newport's chief of police to fill the vacancy created when Chief Benjamin Richards suddenly passed away.

Chief Crowley was no rookie to the force. He was appointed to the department in January 1888, and by all accounts, he was known throughout the city as a fair and honest man, a dedicated officer and one who took pride in Newport.

Before appointing Crowley, the Newport Police Commission had considered a Newport police captain and sergeant for the position, but both declined the promotion due to pension considerations. The chief's salary was only $1,500 a year.

Just three months after taking office, Chief Crowley was put to the test when a former Newport mayor accused him of assault. The alleged incident occurred when the ex-mayor called on the chief to remove a roulette wheel that was being operated on a sidewalk. But it wasn't just the roulette wheel, it was the fact that an American flag was being used as a place to lay the betting money. The chief arrived and removed the flag, but allowed the gambling to continue because the wheel operators had all of the proper permits required under the law. This angered the ex-mayor, and he and the chief exchanged some heated words. As the chief went to leave, he allegedly brushed the ex-mayor with his shoulder.

The following day, the ex-mayor filed an assault charge with the clerk of the court, and an arrest warrant was drawn up. The warrant ended up on Chief Crowley's desk to be signed. Chief Crowley promptly signed his own arrest warrant, and then presented himself before the court and pled not guilty. He was released on personal recognizance, and a hearing was set for the following week.

Research has been unable to determine the outcome of the case. But what is known is that Chief Crowley was given a pay raise of $100 in February 1906, and he served as Newport's chief of police for many years afterward. Therefore, it can be surmised that the charge was dismissed.

THE TIME-TRAVELING TURTLE

It was a pleasant October day in 1909, when Ellijah Phillips of Wickford found a box turtle on the farm of Thomas Rathbun. What made this turtle so different from all other box turtles was that it bore markings on its shell indicating that young Ellijah wasn't the first human to encounter it.

Carved into the shell were three dates, the oldest being 1839, next to which were the initials H.A. The next date was carved forty-one years later by someone named G.H. Huling. The newest date was 1899, carved by N.C. Rathbun,

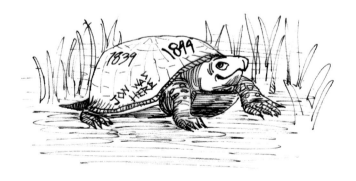

a relative of the then-current farm owner. It was speculated that the oldest initials belonged to Henry Arnold, who was known to have lived in the area of the farm in the 1840s. If true, then the turtle apparently had not ventured very far during the previous seventy years.

Elijah added his own initials and date to the creature's shell before releasing it back into the wild. Since box turtles have been known to live for more than one hundred years, it is possible that the turtle was still making its way around Wickford in the 1940s.

A TERRIBLE DEN OF INEQUITY

Apparently, what went on at "the place" was common knowledge to everyone in the quiet village of Chepachet, but it was tolerated with a wink and a nod. Then, something happened. What that "something" was is not recorded, but it motivated several civic-minded women to file a complaint with Providence County Sheriff Jonathan Andrews, who sent Deputy Mellroy to look into the matter. After a short investigation, Mellroy verified that gambling was in fact occurring in "the place." Worse, it was rumored to involve young children!

Deputy Mellroy conducted a one-man "raid" on the alleged den of inequity on August 24, 1923. There, in the back room of "the place," he discovered a nickel slot machine.

The slot machine was sometimes paying as much as twenty to one in jackpots—nice winnings for those days.

Local children were said to frequent the back room to gamble on it, using their winnings to buy candy at the front counter, where the proprietor of "the place" also sold stamps and envelopes. Stamps and envelopes? Yes, for "the place" was the Chepachet Post Office!

DEAD AT "DEAD POND"

A forgotten and yet unsolved mystery began in North Smithfield on August 15, 1874, when Mr. Alexander Ballou was traveling from Woonsocket to North Smithfield. On that day, as he was passing a place known as "Dead Pond," he saw the body of a man lying at the water's edge. Coroner W. Aldrich was contacted and began his investigation at the scene. Word spread quickly, and before long, two hundred curious spectators had assembled. The coroner asked the crowd if anyone knew the man's identity or had any information as to how he died, but nobody came forward.

The dead man was about twenty-five years old and very well dressed. He had two pipes, a pouch of tobacco, a small key and ten cents in his pockets, but nothing to solve the mystery of his identity. He had obviously been in the water quite a while as there was heavy decomposition. Since there were no apparent signs of violence, the cause of death was determined to be "accidental drowning." He was removed from the area and buried in the North Smithfield town cemetery in an unmarked grave.

A few days later, several people came forward making inquiries about the man. On one occasion, the grave was opened and the coffin lid was raised for viewing, but nobody could identify the remains. Police sent out notices to surrounding jurisdictions, but none reported any missing persons. To this day, the man lies forgotten and still unidentified in an unmarked grave.

A SHOCKING EXPERIENCE

Bicycle clubs were all the rage in the 1890s, and many people rushed to join them. So it was on July 24, 1895, that a group of bicyclists came peddling down Main Street in Woonsocket.

It was a typically warm summer day, and the sidewalks were crawling with pedestrians going about their business. The riders coasted to a stop in front of Fred Arnold's drugstore, where they could find a refreshing drink of root beer or sarsaparilla.

By a strange coincidence, just as the riders were dismounting their bikes, a wire attached to a nearby building suddenly broke loose and fell across the overhead electrical trolley lines. The very end of the wire dropped right into the middle of the group of bikers. Just then, a trolley came along and snagged the wire, which became tangled around the pole that ran from the trolley to the electric wires. Loud popping and showers of flying sparks sent startled cyclists and pedestrians running for cover. One man attempted

to flee with his bicycle, but suddenly thought better of it when he received a jolt from the flailing wire. The scene resembled a Fourth of July fireworks celebration until someone cut the power to the overhead lines. Fortunately, there were no serious injuries.

Just Being a Good Neighbor

Joseph Robarge of Riverside was the type of man who kept an eye on what went on in his neighborhood. He was also the type of man to take action when he saw something that wasn't right.

Late in the night of March 7, 1906, Robarge observed two men attempting to break into a neighbor's house. After arming himself with a revolver, he went over and confronted them. When he demanded to know their business at that hour, one of the would-be burglars drew a pistol of his own and fired at Robarge. The two exchanged several shots at close range, but the nearest anyone came to being hit was when one bullet passed through Robarge's hat, flipping it off his head. Suddenly, the shooting stopped, and both burglars fled into the night. One would think that after a close call like that, Mr. Robarge would have been happy to see the men go, but instead, he gave chase. The gun battle continued until Robarge fired his last shot. When he did, the man with the gun dropped to the ground. As Robarge closed in, the man suddenly got up and staggered off.

Mr. Robarge's neighbors were no doubt grateful for his heroics. However, he didn't consider himself a hero, just a good neighbor.

THE STILL ALARM

Discovering one's car is on fire is upsetting enough, but to find the car burning in one's garage is even more disturbing. On March 24, 1949, a Slatersville man found himself in this exact situation and rushed to call the fire department. Unfortunately, in his haste, he forgot to tell the dispatcher his address. All the firemen could do was to stand ready by their trucks until someone else called in the fire. Unfortunately, due to the delay, the car and the garage in which it was housed were lost. It was said that the flames from the fire, fed by the gasoline in the car's fuel tank, could be seen from Woonsocket.

A FIERY HORROR IN PROVIDENCE

The firemen were asleep at their stations when the alarm bell chimed for a building fire at 88 Mathewson Street. They rolled out of their bunks, dressed quickly and manned the trucks. Within two minutes, the first fire engines on the scene encountered smoke and flames shooting through the windows. It was 3:43 a.m. on January 31, 1921. They didn't know it then, but this fire was destined to be the worst in the history of the Providence Fire Department.

The four-story building occupied the corner of Washington Street and Mathewson, and housed a bowling alley, a restaurant and a pool hall. The flames were spreading quickly, and the chief called for more apparatus to respond. One concern was an occupied hotel directly across the street. Flames were reaching outwards from the upper stories as if trying to touch the hotel. If the fire jumped the street, a huge conflagration would result.

Firefighters quickly threw ladders up against the front wall of the building and scurried to the top with their hose lines. The water drove the flames back, thus saving the hotel. Other streams of water played on nearby buildings to keep them from igniting.

However, it soon became apparent that the burning building could not be saved. The chief determined that the best course of action would be to withdraw and "surround and drown" the fire, while at the same time concentrate on protecting nearby structures. So he gave the order to withdraw. No sooner had he done so, the front wall suddenly buckled and collapsed without warning. Firefighters at the top of the ladders were pitched into the blazing inferno. Others fell thirty feet to the pavement below, where they were immediately buried under tons of bricks and burning debris. It all happened in less than five seconds. There was no time to react.

As the dust cleared, a strange silence fell over the scene. When the initial shock wore off, those unaffected immediately began rescue efforts. Some firefighters ran directly into the flames to rescue fallen brothers, while others began

frantically digging in the rubble. Word of the disaster spread quickly, and doctors raced to the scene to assist in any way they could. Ambulances were in short supply, so many of the injured were taken to the hospital in private cars.

When it was over, four firefighters were dead, and eighteen others were badly injured. As bad as it was, some said it was a miracle that it wasn't worse. The dead were Thomas Kelliher, of Engine 2; Arthur Cooper, of Engine 13; John Teague, of Hook and Ladder 1; and Lieutenant Michael J. Kiernan.

The cause of the fire was never determined.

A GIFT FROM THE HEART

Eight-year-old Pauline was born with a spinal infirmity that caused her great pain, despite having had two operations at Boston Children's Hospital. Her medical care was expensive, and it put a financial strain on the family budget. Doctors felt her condition was permanent, and that she would require a cane or a walker for the rest of her life.

But despite her own hardships, Pauline was always thinking of others. In March 1949, she received some money from a family friend. Her first thought was to give the money to the Easter Seals, an organization that helps children like her. The amount of money is not recorded, but the fact that an eight-year-old girl from Woonsocket felt there were others who needed it more than she did should be an inspiration to us all.

A Marriage Soars to New Heights

Throughout the ages, young couples have tried many unique ways to make their wedding days special. In 1888, one Providence couple took their wedding vows to a new level, so to speak, by getting married in a balloon in front of an audience of thirty-eight thousand spectators.

The wedding of Margaret Buckley to Edward J. Davis took place at the Rhode Island State Fair, held at Narragansett Park in Providence, on September 27. (Narragansett Park stood where the Providence Shipyard is located today.) The wedding was supposed to take place on the twenty-sixth, but it had to be postponed due to bad weather.

Word of the event had spread rapidly, and all day long curious people had been arriving at the park. By the time Reverend E.D. Hall of St. Paul's Methodist Episcopal Church arrived at 4:00 p.m., the crowds had grown to enormous proportions. A gentle wind caused the balloon to sway at its moorings, making some wonder if the ceremony would be called off, but the couple refused to be delayed a second time.

After the vows were said, and the traditional kiss given, the balloon lifted off with Professor James K. Allen at the helm. The couple smiled and waved to the cheering crowds as the balloon ascended into the sky and sailed away.

After such a picture-perfect, romantic ending, the newlyweds no doubt thought there was nothing that

could make the day any more memorable, but they were wrong. The balloon sailed northeast toward Boston, but it ran into trouble over Easton, Massachusetts. The airship came down in a swamp, and the occupants had to hold on for dear life as the wind dragged them across the water. Fortunately, someone heard their cries for help and they were rescued. After changing into some dry clothes, the newlyweds decided it best to continue on to their honeymoon destination by rail.

FRUSTRATED SAFECRACKERS

Just how many sticks of dynamite does it take to blow open a bank vault? A group of crooks tried to find out one night when they broke into the First National Bank of North Smithfield.

The bank was located on the first floor of a two-story building. On the second floor was an apartment occupied by a husband and wife. In the early morning hours of March 15, 1904, the couple was awakened by an explosion that emanated from the bank beneath them. Besides being loud, the blast shattered the glass windows to the bank and knocked pictures off the walls of the upstairs apartment. The time was one twenty-five in the morning.

Peering from his bedroom window, the husband saw two men hiding in the shadows outside. He discovered another at the foot of the stairs that led up to his apartment, and yet another to the rear of the building. He could hear a fifth

man working inside the bank below. He and his wife were trapped, and there was nothing to do but wait and see what developed.

For the next two hours, the burglars set off eleven more charges, each successively stronger than the last. One even caused a section of plaster to drop from the ceiling. Surely, thought the couple, somebody would hear the noise and send a constable to investigate. (Later investigation revealed that dozens of people had heard the commotion, but nobody thought to notify authorities.) Finally, after the last blast, the men gave up and calmly walked to the Congregational Church, where they had left a wagon team in the church stables. They were then seen riding off toward Millville, Massachusetts.

The bank vault was constructed of heavy granite blocks, with double steel doors that were set in stone, and it was equipped with a time lock. Inside was a heavy safe that contained about $5,000 in cash. After failing to blast open the doors eleven times in a row, there was some discussion between the men. It was then decided to put several charges together and set them all off at once. The twelfth charge blew the steel doors inward in a twisted jumble. One door became hopelessly pinned against the safe, thus blocking any further efforts to remove the money. The men gave up and left out of frustration.

The old bank building is still standing today and is used as a private residence.

GOING IN STYLE

When Betty Young, formerly of Foster, arrived at the Pearly Gates, she arrived in style, for she pulled up in her 1989 Cadillac Coupe de Ville. Her husband, Lester, had bought her the car when it was brand-new, and she drove the car until her death in 1994 at age seventy-six. She loved the Cadillac so much that she made arrangements to drive it for eternity. To accommodate the casket, the interior of the car had to be removed. To accommodate the car, a crypt twenty feet wide and eight feet deep had to be dug.

And so it was that, on November 14, 1994, Betty Young was buried in her Cadillac at the Phillips Memorial Cemetery in Foster.

UNSAFE AT ANY SPEED

Another person who wanted to drive the car she loved into the hereafter was Rose Martin of Tiverton. In 1962, she bought a brand-new Chevrolet Corvair, the car Ralph Nader made famous in his book *Unsafe at Any Speed*. When she passed away in 1998, she was buried in her car at the Pocasset Hill Cemetery in Tiverton.

As a footnote to this story, Rose was a retired Tiverton police matron who looked after female prisoners. As such, it was only fitting that uniformed police officers served as pallbearers at her funeral.

GUNPLAY AT A ROADHOUSE

Pretty, twenty-two-year-old Maggie was seething. Her boyfriend, a man named Thompson, had left her for another woman, and this didn't sit well with her. Since the breakup, she had been residing at a Burrillville roadhouse run by James A. Taylor and located near the Ironstone Reservoir.

On the night of September 14, 1895, she set out with a girlfriend to confront Thompson at his drinking establishment in Woonsocket. There, the two argued. Who said what is not important, but the fight was overheard by five men drinking at a nearby table. After Maggie left, they elected among themselves to kill her. How they came to this

conclusion is not recorded, but perhaps it was to gain the good graces of Thompson.

Maggie and her girlfriend arrived back at the roadhouse at 11:00 p.m. and went to bed. A short time later, two of the Woonsocket men knocked on the door of the roadhouse and demanded entrance. Mr. Taylor answered the door, and when he asked them their business, they said they wanted to come in and drink. At the age of sixty-nine, Taylor was not a young man, and perhaps he felt intimidated. Whatever the reason, he let them in. A few minutes later, the other three men arrived. Once they were all inside, the men announced their real reason for being there and asked where Maggie and her friend were.

Taylor denied there were any women on the premises, but the men didn't believe him. Two drew revolvers, while a third produced a knife. At this point, Taylor's housekeeper suddenly appeared, and one of the men pointed his gun at her. Another placed his pistol against Taylor's forehead and pulled the trigger, but miraculously, the gun misfired. Taylor quickly pushed the man away, produced a rifle from behind the bar and promptly shot his assailant in the neck. The man slumped across the bar with blood spurting from the wound. Upon seeing this, the other four men ran out the door and into the night.

Providence County Deputy Sheriff Inman, along with Burrillville Constable Roscoe Wood, responded to the scene and determined that Taylor had acted in self defense. A medical examiner and a local doctor treated the bleeding man. After dressing his wounds, they determined that he would not survive.

Maggie and her friend had slept through the whole ordeal and weren't aware that anything had happened until Deputy Inman woke them. Maggie could only identify the dying man as "Sam" and said he was a good friend of Thompson's. She added that she had never had any problems with him.

Sam's body was removed to a local undertaker's shop, where curiosity seekers were allowed to parade through the establishment to view the body. The autopsy revealed nothing new, and the coroner's inquest resulted in a verdict of justifiable homicide for Taylor.

IT WASN'T CHICKEN FEED

In the days when those "in society" worried about being on the A-list or the B-list, those who threw the parties were constantly looking for new ways to impress. Take, for example, the gala held in honor of Rhode Island's governor, Robert Livingston Beeckman, on August 17, 1915. The event was held at Shore Acres, a spacious villa on Ocean Avenue in Narragansett that commanded a spectacular view of the bay.

Arriving guests were greeted by multicolored electric lights, a novelty for the time, that were strung from the main gate all the way up the finely manicured lawn to the house. The tables were adorned with the finest china and silverware set atop beautiful linen. The governor's table was festooned with a floral display that was arranged in the shape of the Rhode Island state seal and adorned with electric lights.

But what set this party apart from others that summer was the fact that the guests dined inside a giant birdcage. The cage was constructed of wires covered with a gilded net. The tables surrounded a simulated sunken garden that included flowers, plants and singing birds. The birds were real and included canaries, parrots, thrushes and doves.

Female guests received small willow birdcages with toy birds inside as party favors. Afterward, the hosts brought their guests to the Narragansett Casino for coffee and dancing. Everyone agreed that the gala was a success.

WAS THERE A COSMIC CONNECTION?

At 10:20 p.m. on the night of February 27, 1883, a spectacular meteor was seen streaking across the sky over Newport. The blazing object lit up the night sky as the glowing head of the meteor was followed by a long tail of light. One witness to the event was Ocean Avenue's Jonathan Kenny, who reported watching from his piazza as the meteor came down and struck the water far offshore. It seemed to bounce two or three times across the surface before it exploded in a massive eruption that lit the entire ocean and horizon as if it were high noon.

The explosion was followed by an earthquake that rattled windows and knocked objects off of shelves. There were two distinct shocks lasting about eight seconds that were felt as far as Providence to the north; New Bedford, Massachusetts, to the east; and Norwich, Connecticut, to the west.

The incident left many wondering if the meteor and the earthquake were connected, or was it just a strange coincidence?

YOUNG LOVE

Nineteen-year-old Frank and fourteen-year-old Hattie were in love, but she was too young for marriage. Therefore, in January 1881, they decided to elope. Her parents quickly swore out a complaint with South Kingstown Chief of Police Tabor, who determined that the couple had been seen boarding a train in Providence, bound for New Jersey.

Tabor sent a message to the Grand Central Depot Police in New York to watch for them. The order directed that young Hattie be returned to Rhode Island, accompanied by an officer, for which the chief promised to cover all expenses. However, by the time this information was issued to the rank and file, the train had already passed through New York and on to New Jersey.

Detective Stephen Hubbard of the railroad police was assigned to the case. He traced the lovers to a hotel in Elizabeth, New Jersey. From there they were taken to the Elizabeth police station, where they were placed in separate rooms, but not in jail cells. In the evening, the chief of police brought them to his home for dinner. Afterward, Hattie was given a room for the night at the chief's home, and Frank was escorted back to the station, where he spent the night in a chair conversing with the officer on duty.

The couple maintained that they were married, but they had not received their marriage certificate yet. Police allowed them to continue their ruse until the arrival of Hattie's enraged father, who promptly took her home.

The Heroine of Lime Rock

The Ida Lewis Yacht Club sits on Lime Rock in scenic Newport Harbor. The club was once a lighthouse operated by the U.S. Life-Saving Service. It is named for Ida Lewis, the first woman lighthouse keeper in America, whose illustrious career spanned fifty-three years and included eighteen successful rescues.

Ida was born in Newport in 1842, the daughter of a revenue cutter captain. When she was twelve, her father became the keeper of Lime Rock Light, but due to health problems, Ida often helped her father with his duties. When he suffered a stroke in 1858, Ida took over as keeper until a replacement could be found. This was an era when tending a lighthouse was considered "man's work," and the thought of a woman doing it was almost out of the question. The physical stamina required to row a rescue boat through rough seas, as well as the long, lonely hours of isolation, was considered more than a woman could handle. But Ida proved so proficient at the job that she was finally appointed the permanent light keeper. During her first year on the job, she was credited with saving four youths when their boat sank during a storm.

In 1869, she rescued two soldiers during a raging blizzard, when their boat capsized in Newport Harbor. In appreciation, the soldiers at nearby Fort Adams took up a collection and presented her with a gold watch. A short time later, the people of Newport raised funds to purchase a new rowboat to replace the aging one she had been using. It was presented to her by General Ulysses S. Grant, who became president of the United States that same year. Ida became famous when the story of her heroics during the rescue of the soldiers appeared in *Harpers Weekly*, a popular magazine of the time.

In 1889, she rescued her own uncle, who fell overboard while on a fishing excursion.

Ida was pretty, and no doubt had more than her share of marriage proposals. She married a man named Wilson in 1870, but they separated two years later. Afterward, she resumed her solitary life at Lime Rock and never remarried.

Ida made her last rescue in 1907, when she was sixty-five. On that occasion, a woman who had been on her way to visit the lighthouse fell overboard from a rowboat.

In October 1911, Ida's brother went to visit her at the lighthouse and found his sister lying on the floor, having suffered a stroke. There was nothing doctors could do, and she died a short time later.

Shortly after Ida's passing, Captain Evart Jansen and his wife took over at Lime Rock. When their daughter was born at the lighthouse on December 17, they named her Ida Lewis Jansen.

During her long years of service, Ida received numerous awards, and she was well known for her work, not only

throughout New England, but also around the world. Perhaps the greatest honor was the renaming of the lighthouse to the "Ida Lewis Lighthouse" in 1924. This was the only time in the history of the U.S. Lighthouse Service that such an honor was bestowed.

TURKEYS IN THE WHITE HOUSE

Thanksgiving is an American holiday, and each year the press runs a story about how the president always gives the White House turkey a last-minute reprieve from the roasting pan. However, this was not always the case. What many are unaware of is that, for more than forty years, the White House Thanksgiving turkeys came from a private citizen in Rhode Island and were thoroughly enjoyed by a succession of presidents.

Horace Vose owned a turkey farm in Westerly in the mid-1800s. In 1870, he took it upon himself to send a Thanksgiving turkey to President Grant. The bird was so well received that the following year he did it again, and he continued to send a turkey for the next forty-three years.

In 1913, his gift created a dilemma at the White House, when a second bird was sent by South Trimble, who was a member of the House of Representatives and a close friend of President Wilson. The turkey sent by Mr. Vose weighed thirty-seven pounds and was said to have been raised on a special diet. The one sent by Mr. Trimble was several pounds lighter, but had been fed red peppers to give it added flavor.

On the surface, this would not seem like such a difficult decision. But in politics, perception is everything, and how one is perceived can mean the difference between getting and not getting votes. Mr. Trimble was from the South, and Mr. Vose was from the North. One was a politician, the other a businessman. One had established a Rhode Island tradition, the other was beginning a new one for Kentucky. Whatever the choice, somebody's feelings would be hurt.

So which turkey had the honor of gracing the White House dinner table that year? It was said the decision would be left to Mrs. Wilson, who no doubt solved the problem in the most diplomatic way possible. Whichever bird it was, the White House declined to specify.

THE INVASION OF BLOCK ISLAND HAS BEEN POSTPONED

On July 22, 1902, two hundred United States Marines landed on Block Island near New Harbor, on the northwest side of the island, and set up tents. They were there to defend against a military invasion that would take place the following day. The "enemy troops" would be coming ashore from two navy battleships, the *Alabama* and the *Kearsarge*, both of which were anchored about a mile off the coast. The exercise was part of scheduled "war games."

But the simulated battle never took place. On the morning of the twenty-third, bad weather had set in, and the "invasion" was cancelled. The two hundred marines

simply packed up and returned to the battleships. The ships were last seen heading out to sea.

WHO'S DRIVING?

Religious leaders are always looking for ways to increase attendance at spiritual gatherings. In 1899, the Reverend Charles E. Preston came up with a novel idea that was a first for Rhode Island: he put a church on wheels.

There was a time when ministers would travel to areas that didn't have a church and preach in a meetinghouse, private home or any other convenient place. Reverend Preston took this one step further and decided to bring his church with him. The idea came to him in the early 1890s, when, as pastor of St. Mathew's Church in Jamestown, he wanted to make it easier for those living at the northern tip of the island to attend Sunday services.

He eventually raised $3,000 and made his dream a reality. The completed church was eighteen feet wide, twenty-seven feet long and eighteen feet tall to the roof peak. A seven-foot steeple adorned the peak over the front entrance, bringing the total height to twenty-five feet.

The wheels required to move it were over nine feet wide and were constructed at the shop of J.R. Bachelier in Newport. They were attached to a chassis, on which the church sat. Covers were designed to hide the wheels when the church was stationary to give the building the appearance of permanence.

The inside of the church was well appointed with oak fixtures, stained-glass windows and lush carpeting. There were fourteen pews on either side of a three-foot-wide aisle and an area for an additional twenty seats. In all, the building could comfortably hold one hundred people. There was also an altar, an organ and a robe room, complete with a wardrobe.

The church, weighing about twelve tons, was pulled by oxen. It was first brought to a location near present-day Carr Lane, where it was consecrated. In June 1899, it was hauled farther north to the Conanicut Park neighborhood, where it remained throughout the summer.

Just how long the church was in use is not recorded, but it is said that it still survives today as a private home on Harbor Street, not far from the Newport Bridge.

A Murderous Prison Break Attempt

On the afternoon of April 25, 1930, two men entered the visiting area of the state prison in Cranston after giving the officer on duty fictitious names. Visitors at the prison were separated from the inmates they were there to see by a metal screen so that nothing could be passed back and forth. The only way for someone to gain direct access to the inmates was to open two locked gates at one end of the room.

Corrections Officer Harry McVay was working on the visitor's side of the screen that day. While the two strangers were talking with two inmates, the warden's daughter wanted to pass through the set of locked gates to get to the prison barbershop. As Officer McVay was unlocking the first gate, one of the strangers suddenly produced a pistol and began beating McVay with it. McVay tried to defend himself, but his assailant put the barrel of the gun to the officer's chest and fired. McVay crumpled to the floor, with blood spurting from the wound.

Those who witnessed what came next gave varying accounts. Some said both gates were open, while others maintained that only one was open, but somehow an inmate on the other side of the screen got possession of a gun and took a second officer hostage.

Upon hearing the commotion, the prison chaplain, John Sullivan, appeared and tried to negotiate with the inmate holding the other officer hostage. While this was taking place, a trustee named Peleg Champlin activated a siren

that indicated a prison break was in progress. As he did so, he was gunned down and killed.

The strangers tried to shoot the locks off the gates to free their friends, but they were unsuccessful in their attempts. With sirens wailing and police on the way, they fled, leaving the armed inmate alone with his hostage. On their way out of the building, they encountered the warden and shot at him, but missed. They managed to escape in a blue sedan that was driven by a third man. All three were later apprehended by Providence police.

Police officers from Cranston and Providence, along with state police, descended on the prison. Using tear gas and riot guns, they stormed the visiting area. As police closed in, the armed inmate took his own life, but thankfully spared the corrections officer.

Officer McVay died from his wounds later that day. He was the first Rhode Island corrections officer to die in the line of duty.

Rhode Island's First State Police

It is generally accepted that the present-day Rhode Island State Police agency was established in 1925. What many don't know is that there was another state police force in Rhode Island that preceded this one, and it was established fifty years earlier. The origin of this organization had its roots in Prohibition.

Prohibition in America didn't begin and end in the 1920s. In fact, the first attempts to ban the sale and consumption

of alcohol in Rhode Island began as early as the 1820s and continued to gain momentum as the century progressed. In 1852, those involved in the temperance movement finally succeeded in passing the "Maine Law," which banned the use and sale of liquor in Rhode Island. Enforcement of this law was left to county sheriffs and local authorities, and was spotty at best. The law was later repealed in 1863.

In 1874, a new law banning alcohol was enacted by the Rhode Island General Assembly. This time, enforcement was carried out by special constables with statewide jurisdiction to enforce any and all liquor law violations. They were initially called the Rhode Island State Constabulary, but the name later changed to the Rhode Island State Police.

The ranks of the state constabulary consisted of one chief constable and seven deputy constables. The first chief constable was a man named Northrup. These were the first law enforcement officers in Rhode Island to have legal authority throughout the state. However, they only had the authority to enforce Prohibition laws.

Shortly after their inception, they made their first "raid" in West Greenwich, where a sizeable amount of liquor was seized. This action was quickly followed up with more raids in Providence and Woonsocket.

The Providence raid became the first test case for the new agency as not everyone recognized its authority. A dispute arose between the constables and the local United States marshal over who should take possession of the confiscated liquor. The Providence chief of police sided with the marshal, and the matter wound up before the General Assembly.

Prohibition wasn't any more popular in the 1870s than it was in the 1920s, and it wasn't long before the law passed in 1874 was repealed.

In 1886, a new Prohibition law was enacted, and the state constabulary was revived as the Rhode Island State Police. This time the agency was organized with one chief and ten constables. The first chief was Charles R. Brayton, a well-known political figure in the state. He only served as chief for ten months and three days. When he resigned, he was replaced by Edward F. Curtis.

The new state police weren't popular with those who wanted to drink. Under the new law, they had the authority to enter a private home without a warrant, as long as they were searching for liquor. In addition, they could arrest a homeowner and hold him for up to twelve hours while they investigated any allegations against him. Thankfully, this law, too, was repealed, and when it was, the state police force was disbanded.

Today's Rhode Island State Police force was established for entirely different reasons and has come to be known as one of the finest in the country.

IT'S ALL IN THE WRIST

George W. Boss was a longtime railroad engineer with the New York, New Haven and Hartford line. He had been at it for so long that everything had become second nature to him, from how to drive a locomotive to what a danger

signal should look like. It was this knowledge of railroad procedure that saved him and his train from being robbed on a lonely stretch of track near Woonsocket.

On the night of September 25, 1903, George was driving his train south toward Providence when he saw a green lantern on the tracks up ahead indicating that the line was clear of trouble. Suddenly the lantern changed from green to red, indicating danger ahead. George instinctively reached for the air brakes, but then his sharp eye detected that something wasn't right. He knew immediately that the man swinging the lantern wasn't an experienced railroad employee. Instead of the easy back and forth swing he was used to seeing, the movements were jerky and unsteady. Something told George that whoever was holding the lantern didn't work for the railroad, and he suspected they wanted to stop the train to rob it.

George had to make a quick decision. If he stopped and robbers were waiting, he risked the lives of everyone aboard. If he pressed on, and the danger signal was real, a huge wreck could be the result. George went with his gut and opened the throttle. The train barreled down the tracks toward the swinging lantern. At the last moment, a dark figure was seen leaping to one side as the train roared past. A few miles down the line, it was obvious to George that his instincts had been right.

It was surmised by authorities that the robbers may have been after a mail train that was scheduled to pass by a short time after the passenger train operated by Mr. Boss. For the next few days, deputy sheriffs rode the trains to foil any future thoughts of robbery.

HE NEARLY DROWNED IN A BALLOON

Professor James K. Allen came from a family of Rhode Island aeronauts who pioneered recreational hot air ballooning. Going aloft in those early balloons was not without its risks, but the risk of drowning in one's balloon was no doubt considered minimal. Yet that's what almost happened to Professor Allen.

The incident began on July 4, 1906, at the Providence Municipal Celebration. Professor Allen was scheduled to take off at about noon in his one-hundred-foot-tall balloon as part of an exhibition, but bad weather delayed the ascent until about 4:30 p.m. This delay proved to be an omen of what was to come.

Once aloft, Professor Allen and his balloon sailed eastward toward Seekonk, Massachusetts, where he landed briefly at about five o'clock. A short time later, he took off again, headed toward North Attleboro, and landed there about a half hour later. After that stop, he took to the air again and was last seen heading for Scituate, Massachusetts.

However, the air aloft was still unsettled, and when the wind direction shifted, Professor Allen found himself being blown out to sea. The night was growing dark, and the professor had no idea where he was. When he discovered he was over water, he let out five hundred feet of drag line. The rope caught the water and brought the balloon down to about one hundred feet as the wind continued to carry

Forgotten Tales of Rhode Island

the huge craft out to sea. The situation was not good. The balloon didn't carry any life preservers or rescue provisions, and the professor was at the mercy of the wind.

At one point, he spotted a small boat and signaled that he was in trouble. The boat attempted to come to his aid, but the balloon was traveling too fast and the boat couldn't keep up. At about midnight, the balloon basket suddenly dropped into the ocean and began to sink. All the professor could do was hold on to the upper ropes to keep from being washed away by the waves. It then occurred to him to dump some of the sand bags used for ballast, and the balloon slowly rose out of the water. When the basket dunked him a second time, he was forced to repeat the process. He spent the rest of the night wet and miserable.

At dawn he saw a steamship and tried to signal it, but apparently the ship's lookout didn't see the huge balloon bobbing over the water, and the ship sailed on. About two hours later, he saw a fishing schooner and some men in small boats near it. After dropping a rope from the balloon to the men, they successfully brought the aircraft down and thus rescued Professor Allen. They also managed to save his balloon.

Meanwhile, when Professor Allen failed to arrive in Scituate, it was surmised what had happened, and he was given up for lost. It wasn't until a day or so later, when the schooner arrived in Boston, that his fate became known.

One would think that after such a harrowing experience the good professor would have second thoughts about taking any further flights in a balloon, but such was not the case. In

fact, Professor Allen had been seriously injured in a balloon accident in July 1892, when he was taking off from Dexter Field in Providence. On that day, the drag lines had become fouled in some trees, and the professor and his passenger were pitched out and fell nearly sixty feet to the ground. The professor suffered several broken bones, but he took it all in stride as simply the cost associated with ballooning.

I'D LIKE TO THANK THE ACADEMY

It wasn't a prestigious award. Nor was it one that anyone would aspire to obtain. But it was worth five dollars—and five bucks is five bucks.

It all happened at the Newport Opera House on a Saturday night in February 1906, when the house was full of tuxedo-clad men and elegantly gowned women. Mr. Moulton, of the Bennett-Moulton Company, took the stage and announced that he would give five dollars in cash to the homeliest man in Newport. All the winner had to do was come up onstage and collect his prize. The only stipulation was that the man had to be accompanied by a lady.

Mr. Moulton's motivation for the offer was unclear, but the announcement no doubt sent muffled laughter rippling through the audience as those present waited to hear the punch line. But Mr. Moulton insisted that it was not a joke. He spent nearly five minutes waving the five dollars in the air and asking if there were any takers, but the men of the audience remained seated. After all,

who wanted to become known as the Homeliest Man in Newport? Finally, one man, who had been sitting with a woman, rose from the audience and made his way to the stage. Mr. Moulton presented him with the money, and it was as simple as that. There was no trophy, plaque or medal to go with the title—just five easily made dollars. And five bucks is five bucks, after all.

SERVES HIM RIGHT

They say Justice is blind, and such may be the case, but sometimes Justice prevails. Take the case of three men in June 1887. A man named Gardner filed an assault charge against a wealthy man named Steere of Providence. By the time the case went to trial, Gardner had hired an attorney to sue Steere. But the case fell apart when Gardner stated in open court that the charge had been filed in an attempt to get money from Steere. He added that any money gained would be split between himself and his attorney. Gardner's attorney was called before the court, and he adamantly denied that he and Gardner had reached any

such agreement and promptly withdrew from the case. The lawyer asked the court to investigate the matter, but the judge ruled that the court could not prosecute the case and at the same time sit in judgment of it.

The case against Steere was, of course, dismissed, and Gardner was sued by his own attorney for slander.

THE STATEHOUSE CANNON

There is a Civil War–era cannon on display at the Rhode Island State House that has a cannonball jammed into the end of the barrel. It is perhaps the most interesting relic of the War Between the States that Rhode Island has.

The cannon is made of cast bronze and was commonly known as a "Napoleon" by those who used it. Napoleons were the most common field piece used by both sides in the Civil War. This particular cannon belonged to the First Rhode Island Light Artillery and saw action at the famous Battle of Gettysburg, the undisputed turning point of the war.

On July 3, 1863, during the third day of the battle, the cannon was being used against opposing forces when a Confederate shell struck the barrel and exploded. Two loaders, William Jones and Alfred G. Gardiner, were killed as a result. The dent left by the shell can still be seen today.

In an attempt to put the piece back in action, other soldiers attempted to reload it, but the cannonball became

stuck in the breech. As the cannon began to cool, the ball became hopelessly jammed and remains so to this day.

Afterward, the cannon was put on display in Washington, D.C., and later brought to Rhode Island in 1874. In 1962, nearly one hundred years after the Battle of Gettysburg, it was discovered that the cannon still held a live powder charge. It was removed from the statehouse, and army specialists were called to disarm it. The only other time it has left the statehouse was in 1988, when it was taken back to Gettysburg for a reenactment of the famous battle.

GRAVE SECRET

There is a grave in the Town of Foster that was once suspected of holding the key to solving a murder. Perhaps it still does.

This story begins in New York City, in 1902, with the murder of an artist named Albert C. Callier. The killer placed his body in a steamer trunk and then put the trunk in storage. The trunk lay undisturbed until November 1908, when its contents were discovered. New York City Police were notified, and Lieutenant James J. Kane was assigned to the case.

The body was positively identified through dental records. On the outside of the trunk was the name of its owner, who was a known associate of Callier's and who disappeared in 1906. Lieutenant Kane's investigation

eventually led him to a man with the same name living in Foster, Rhode Island.

The circumstances surrounding the case seemed to fit the man living in Foster. Information gleaned by Lieutenant Kane indicated that the man had come to Rhode Island on November 1, 1906, and had moved to Foster in April 1907. He arrived with his wife, bringing nothing except what was on their backs. The wife had mentioned on occasion that she had furniture and clothing stored in New York, and at one point she allegedly went to retrieve some of it, but returned empty-handed.

The man, it was said, was very secretive about his past and took care not to discuss it. Some claimed that he was always concerned that someone was following him. Perhaps there was some truth to his paranoia, for on the night of November 8, 1910, the man met with a fatal accident that some suspected was murder. He was driving a four-horse wagon loaded with wood, headed for Providence, when he somehow fell under the wheels and was crushed to death. A loaded revolver was found in his pocket, yet he had never been known to carry one before. There was speculation by some that he had been hit over the head and then placed beneath the wagon, but this was never proven.

Two days after the man met his fate, his wife supposedly killed herself by ingesting poison.

In order to close the case, Lieutenant Kane had to be sure that the man buried in Foster was the same man who was wanted in New York. If it was, then the case was closed. But if it was not, then he still had more searching to do.

On December 7, 1910, the lieutenant went to Providence and met with police there. The following day, he arrived in Foster with the intent of opening the grave and making a dental comparison as a way to ID the body. However, his long journey was for naught, for the Foster Town Council, after seeking an opinion from the state attorney general, declined to issue the required permit to open the grave.

Thus, Lieutenant Kane had to return to New York, not knowing if he had solved a murder or not. (The man's name in this story was deliberately omitted due to the fact that it was never proven he was the killer.)

PIRATES IN NEWPORT

It is common knowledge that pirate ships once prowled the waters of Rhode Island during the eighteenth and nineteenth centuries, but how many are aware that the profession was still practiced in the twentieth century? Such was the case of the *Dorado*, a pirate ship that appeared in Newport Harbor on October 7, 1905.

The *Dorado* was black and sleek, with a mast that had been reconfigured to make it appear more like a yacht. But the disguise didn't fool anyone, and the ship was recognized right away for what it was. Over the next few days, police kept close tabs on the crew, and when crewmen began nosing around the shipyard, authorities made it clear that they were no longer welcome.

The *Dorado* weighed anchor, but not before a small boat was stolen from a barge anchored nearby. The barge owner went searching for his boat and located it tied alongside the *Dorado*, which was anchored in Narragansett Bay. He immediately returned to Newport and notified authorities. Newport's chief of police, along with Newport County Sheriff Anthony and three other officers, set off to retrieve the boat and arrest the offenders.

As their boat approached the *Dorado*, a man appeared on deck. When asked about the small boat, the man said it was his. When he was informed that it had been reported stolen, he suddenly produced a shotgun and pointed it toward the officers. The police wisely backed off and returned to Newport for more help. The navy cutter *Mohawk* was in port and offered assistance, which was gladly accepted.

In the meantime, the pirates had abandoned the *Dorado* and gone ashore near Tiverton in the stolen boat. When authorities boarded the abandoned ship, they found a large quantity of stolen goods. Among the goods were a box of dynamite and a bottle of chloroform.

While police were inspecting the *Dorado*, a boat identified as the *Bessie* approached and hailed them as friends. As the *Bessie* maneuvered closer, it suddenly became clear to its crew that it was the police, and not their pirate buddies, who were onboard the *Dorado*. The *Bessie* suddenly turned about, with the navy cutter in hot pursuit. Before the cutter could overtake it, the *Bessie* was run ashore and the crew escaped. Further investigation revealed that the *Bessie* was also loaded with stolen goods, and the boat matched the

description of one stolen from the Edgewood Yacht Club in Cranston.

On October 24, a man named Steiffel was arrested in Providence. He confessed to being aboard the *Bessie*, but insisted that he had never stolen anything. He admitted that he had been in partnership with a man named Jackson since early September, but he stated that he believed Jackson had been drugging him with chloroform. He indicated that, on a number of occasions, he had gone to sleep aboard the *Dorado*, only to awaken hours later with the ship in a different location. He believed that it was while he was unconscious that Jackson would leave the ship and steal from other boats.

Steiffel was brought back to Newport, but not as a prisoner; rather, he was a "guest" of the city who was willing to help the authorities solve the whole mystery. Instead of being placed in the Newport Jail, he was given a room at a local hotel. The following day, he was turned over to Cranston's chief of police, John Bigbee, on the charge of stealing the *Bessie*. Back at Cranston, Steiffel pled guilty to the charge and was given one year in prison. In the meantime, authorities were still looking for Jackson and his cohorts.

It took weeks for authorities to track down the owners of the stolen goods. The thieves had been busy, having traveled from New Bedford to New York and everywhere in between.

It was noted by one news article that the whole incident had sparked a renewed interest in pirate dime-store novels.

Getting Carried Away

In August 1955, northern Rhode Island saw some of the worst flooding of the century. The remains of two hurricanes dropped up to twenty-nine inches of rain over a period of three days. But the "straw that broke the camel's back" came when the Horseshoe Dam in Blackstone, Massachusetts, broke on August 19. Without warning, billions of gallons of water went rushing downstream in a literal wall of water. In Woonsocket, the Blackstone River rose at the rate of one foot per minute!

Along the riverbank, the rushing water was so powerful that it eroded the shoreline and carried away trees, rocks and other debris. Some of the worst erosion occurred at the Precious Blood Cemetery, located on Harris Pond near the dam break. There, the water ate into the cemetery hillside and opened numerous graves. Headstones, bones and caskets were carried downstream in the rushing torrents. Some of the caskets were smashed into mill buildings lining the river bank. Others were later seen floating down side streets, where they eventually came to rest in front yards. When it was over, workers were faced with the gruesome task of cleanup. Inevitably, some items were never recovered.

The cleanup work took months, and when it was over, the incident began to fade from memory. Then, thirteen years later, on August 27, 1968, four youths playing along the Blackstone River in back of the Owens-Corning

Fiberglass Plant discovered the rusting remains of a metal casket half submerged in the mud. Police were notified, and when the casket was opened, they found it full of sand, silt and pebbles, mixed with skeletal remains. A tow truck was used to pull the fifteen-hundred-pound casket to shore, and the remains were transported back to the Precious Blood Cemetery, where they were interred in a plot with other unidentified remains recovered after the flood.

How many other items from the Precious Blood Cemetery still lie hidden in the silt along the river? That remains to be seen.

BACK BEFORE DINNER

On September 1, 1944, two teenagers, Amy Heddenberg, fifteen, and William Smythe, sixteen, were on Narragansett Bay enjoying some late-season sailboating before autumn closed in. It was the third summer of World War II and the newspapers were full of accounts of the Allied efforts. To the two teens, the war probably seemed very far away that afternoon. Little did they know they were about take part in the rescue of a downed army pilot.

As their boat skipped across the water, a U.S. Army P-47 Thunderbolt cruised overhead on a routine training flight. Suddenly, the plane developed engine trouble, and the pilot, Lieutenant Charles W. Turner, opted to set down in the water instead of trying for shore. The plane splashed into Narragansett Bay a mere three hundred feet from the sailboat.

The youths, surprised and awed by the sight, watched helplessly as the plane sank beneath the waves and took the pilot with it. But a few moments later, the pilot bobbed to the surface and signaled for help. Turning the boat in his direction, they quickly hauled him aboard and made for the Warwick shoreline, coming ashore at Stokes Street.

The pilot was relatively unhurt and asked only to be returned to Hillsgrove Airport, where he was stationed. Patrolman Albert Izzi of the Warwick police stepped forward and offered to drive him.

In the meantime, officials at Hillsgrove had been notified of the crash. They, in turn, notified the naval stations at Quonset Point and Jamestown. However, before rescue operations could get underway, Turner, dripping wet, was standing before his commanding officer, reporting for duty.

As a footnote to this story, this was not the first accident involving the P-47 flown by Lieutenant Turner. About a month earlier, another pilot had made a forced "hard landing" at Hillsgrove Airfield while flying the very same plane.

AN UNUSUAL RESCUE

On December 21, 1958, the alarm bell rang at Providence fire stations for a fire at 67 Ashmont Street, with persons possibly inside. A call like that will send a firefighter's adrenalin surging through his veins. For one Providence fireman, Private Howard H. Williams, the call had a special cause for concern—it was his house!

Williams raced to the scene, no doubt fearing the worst, yet hoping for the best. Upon arrival, he discovered that his prayers had been answered. As he quickly led his family out of the smoke-filled apartment, other firefighters extinguished the flames. The cause was said to have been an overheated radiator in the kitchen that ignited some papers in a wastebasket.

Houses "Bombed" in Middletown

On September 22, 1956, a family that lived on Stockton Drive in Middletown arrived home to find the house surrounded by police cars and fire trucks. When the head of the household asked what was going on, he was told by police that the house had been hit by a bomb dropped from a passing military jet, and the bomb had failed to explode.

About an hour earlier, the family had been sitting at the kitchen table when they decided to go shopping. According to neighbors, about fifteen minutes after they left, a navy jet passing overhead dropped a bomb that made a direct hit on the home. The bomb tore through the roof and plunged down through the house, smashing through the very kitchen table where the family had been sitting. It then deflected out through the kitchen wall and embedded itself in the side yard.

Officials from the Quonset Naval Air Station determined that the bomb was in fact a "dummy" used in training. They felt its discharge had been accidental, due to wind pressure pulling it loose from a faulty bomb rack.

The Stockton Drive house wasn't the only Middletown home to be damaged by falling military debris. Almost a year to the day later, a Connecticut National Guard jet was passing overhead when two exterior fuel tanks ripped loose. One landed harmlessly in a garden, but the other made a direct hit on a house in the 1700 block of West Main

Road. Fortunately there were no injuries, but a young girl had been doing her homework in an adjacent room when the tank hit. It can be assumed that she had a great show-and-tell story for school the next day.

DUMB CROOK STORY

Most people with outstanding criminal warrants try to avoid the police, but one man actually went to the police station and applied for a job.

In October 1994, the Bristol Police Department was accepting applications for police officers. There were 294 applicants. One of those applicants was a man who had an outstanding warrant for his arrest because he had failed to appear in court to answer the charge of driving with a suspended license. This information came to light when investigators ran a routine background check on each applicant. Police simply contacted the man and asked him to come to the police station to discuss his application. When he came in, he was arrested.

A HORRIBLE HYPNOSIS

A bizarre incident occurred on the night of May 16, 1907, at the Woonsocket Opera House that left many shocked and horrified. A hypnotist was giving an exhibition, and at one point he asked for a volunteer from the audience to

take part in the act. A man came forward and was quickly put under hypnosis. As proof that the man was now in a trance, the hypnotist placed him between two chairs, with his feet on one, his head on the other and nothing to support his body in between. To the amazement of the audience, the man remained stiff as a board and did not fall. The hypnotist then placed six hundred pounds of rocks on the man's abdomen and offered to let another volunteer smash the rocks with a sledgehammer. A muscle-bound blacksmith came forward and offered to do the deed. When the blacksmith dropped the first blow of the hammer, the chair supporting the hypnotized man's head gave way and the body fell to the floor. At the same time, the basket of rocks shifted forward and crushed the man's head, killing him in full view of the audience.

PUT THE WET STUFF ON THE RED STUFF

Everyone knows that firefighter's fight fires, but who do they call when it's their own station that is burning? The volunteers of the Meshanticut Park Fire Company in Cranston faced this very question, when on February 1, 1949, they answered the fire alarm only to discover that it was their firehouse that was on fire.

The blaze was extinguished by both volunteer and paid firefighters from other stations, but not before significant damage had been done. The fire was believed to have started in a pile of rubbish next to the building.

The Badge that Traveled the World

During World War II, John E. Conley Jr. of Warren served in the United States Army with the 242nd Infantry Regiment. Before joining the army, he had been a member of the Central Fire Company of Warren. While he was overseas fighting, he carried his fire department badge with him as a memento of home.

In March 1945, the Town of Kaiserslautern, Germany, was captured by Allied forces. It was in this area that John lost his fire badge and figured that it was gone forever. After the war, he returned home and resumed his life. The fire company issued him a new badge, and he forgot about the old one.

Unbeknownst to John, his badge had been found not long after he lost it by a fellow American soldier named Christian R. Westphal of Long Island, New York. Westphal carried it with him for the remainder of the war and took it home afterward. There it lay among some miscellaneous possessions for almost ten years. Then, in 1955, he came across it again and decided to see if he could track down its owner. He contacted the fire company, and since Conley was the only member who had been in that area of Europe, it was easy to determine to whom it belonged. The badge was returned to its rightful owner just before Memorial Day.

THE GREAT GALE OF 1815

Those who think that extreme weather is a modern phenomenon should consider the gale that devastated Rhode Island on September 23, 1815. To date, it is probably the worst hurricane ever to strike New England.

It began on the twenty-second with heavy rains that caused streams to rise and streets to flood. Then the weather seemed to clear, and many believed the storm was over, but such was not the case. Later in the day, the rain returned, accompanied by high winds that continued to grow stronger with each passing hour.

In all of New England, Providence suffered the worst. The tidal surge was ten to twelve feet above normal. Ships were pulled from their moorings or torn away from docks. The relentless surf carried them inland, where the helpless vessels smashed into bridges, homes and commercial buildings. People seeking refuge in those buildings were also carried away. The swirling water became filled with flotsam and bodies. Everything was driven into the great salt basin that once occupied the spot where Water Place Park is today. When the storm was over, ships and wreckage lined the shore six feet above the high-water mark.

Inland, hundreds of homes had their roofs blown off and chimneys pushed over. The winds were so strong that salt spray from the ocean was carried forty miles inland and settled on trees. The residue caused the leaves to curl and

fall prematurely, leaving a landscape that more resembled November than September. The sea salt also settled on the ground and leached into wells and streams, causing them to have a briny taste for months afterward.

Thousands of trees blew down, some killing livestock and men alike. So as not to let them go to waste, some people used the trees as firewood, but most were taken to sawmills and turned into lumber. Many of the homes and buildings that were destroyed in the storm were rebuilt and repaired with wood from these trees. Some of these houses are still standing today.

The devastation reached from Maine to Delaware, with thousands of lives lost. The exact number of dead has never been determined as many bodies were never found. If there is to be a positive side to this storm, it would be that Providence emerged as a brand-new city.

A Man Ahead of His Time

In August 1926, Arthur C. Gould of Smithfield opened "Fliers Haven," which was perhaps the first "aircraft repair and service station" in the country. It was a place where aviators could land for fuel and repairs much like a motorist could do at a roadside garage. Mr. Gould envisioned a time when such service stations would dot the landscape all across the country.

In fact, it was the automobile gas station that had given him the idea. Most aircraft of the era were open cockpit

biplanes, constructed of wooden framing that was covered with doped canvas. The propeller-driven engines were about as reliable as any automobile of the era and crash landings were not uncommon. The biggest problem for any pilot who found himself in trouble was finding a place to set down. The next was finding a way to effect any needed repairs. Besides repairs, aircraft need high-octane aviation fuel and a special oil mixture, something not found at regular gas stations.

The aircraft service station was established on Mr. Gould's twenty-seven-acre farm on Ridge Road. It had a traditional runway, as well as a four-hundred-foot-long pond to accommodate seaplanes, plus a blacksmith shop, machine shop and woodworking barn.

To help flyers locate his farm, he made signs on the ground with lime. The letters were fifteen feet long to be sure they could be read from the air and included directional arrows.

At the time he announced he was open for business, Gould was still waiting for his first customer; a fact that didn't seem to bother him. For Mr. Gould was an entrepreneur and had a hand in several other businesses.

THIS JUST IN

On November 19, 1909, a local newspaper was the first to break the story of scandalous behavior taking place within the Cranston Police Department. The unauthorized

activity, taking place both day and night, was said to be confined to the Edgewood Precinct. Rumor had it that even private citizens were involved. What sparked this breaking news story? Checkers! That's right, checkers. The officers were playing checkers while on duty.

This was no laughing matter, for not only were the officers playing checkers, but they were also seen, on several occasions, not wearing their uniform coats after 6:00 p.m., which was a clear violation of the rules and regulations of the department. Furthermore, local residents frequently stopped at the police station to chat and sometimes joined the fun. It was even suspected that onlookers might be betting on the outcome of some of the games.

Chief of Police Patrick Trainor was quick to react by issuing an order prohibiting games of any kind in Cranston's four police stations.

THE SKELETON GHOST OF CHRISTMAS PAST

The telling of ghost stories was once a popular way to celebrate the Christmas season. In 1879, teenagers at the Brown Mansion in Newport took the storytelling one step further.

The teens were prone to playing practical jokes, and the visiting relatives and houseguests had to constantly be on their guard. One popular joke was the substitution of a peeled raw potato for a bar of soap on bedroom nightstands. Another was sewing the sleeves of nightshirts closed. But this was all held in good fun.

One evening, as the household sat in the living room around a crackling fire, the subject of ghosts came up. One person after another began to relate allegedly true ghost stories that they had personally witnessed. One visitor from Philadelphia was a medical student and said that he was intimately familiar with ghosts. He added that they didn't frighten him in the least.

Little did he know that he had already been selected to be the victim of a practical joke. Without his knowledge, someone had slipped into his room and painted a skeleton on the wall using phosphorescent paint. The phosphorus would absorb the light in the room and yet remain virtually invisible until the lights were put out.

One young lady brought up the fact that the very room in which the medical student was staying was reputed to be haunted. Legend had it that a priest had committed suicide in the room many years ago and sometimes appeared in the form of a glowing skeleton. Those who saw the skeleton were best advised to kneel down and confess their sins or face the skeleton's wrath. The medical student seemed unperturbed by the story and added that, should he meet the skeleton, he would take its bones back to Philadelphia and study them.

As the hour grew late, everyone began to drift off to bed. The teenagers made a great show of saying good night to one another and dallied until the medical student took his leave.

Once he was in his room, the playful teens quietly gathered about his door. It wasn't long before the man was

ready for bed and turned out the light. It was then he saw the glowing skeleton on the wall. Above the skeleton was written, "Confess your sins!"

It was reported that the medical student immediately began to loudly confess his "sins," which involved kissing three of the young women in the house. The three women named were among those listening at the door and were none too pleased with these revelations. One by one, they fled in embarrassment, and the others in the group followed suit lest something be said about them.

In the end, everyone was left debating who had played the better practical joke, the teens or the medical student.

STUNT FLYING OVER NEWPORT HARBOR

Early military aviators were a special breed—hand selected for their courage, strength and adaptability. In the 1920s, aviation was still relatively new, with newer and more powerful aircraft constantly setting new speed, distance and altitude records. This fact undoubtedly led to many accidents as pilots pushed their aircrafts past the limits of what they were designed to do. One such incident occurred on July 2, 1928, when a military seaplane carrying two navy fliers crashed in Newport Harbor.

The plane was piloted by Commander Thalbert N. Alford, with Lieutenant Commander William Butler Jr. aboard as an observer. Commander Alford had been stunt flying with the plane, going through a series of

loops and rolls five thousand feet over Narragansett Bay. Stunt flying was not prohibited in those days, and in some ways, it was even encouraged in order to test an aircraft's limitations.

As crowds looked on, the plane made three successive loops before it suddenly went spinning out of control into Newport Harbor. The plane slammed nose first into the water, throwing up a spectacular plume of liquid. Butler managed to free himself and floated to the surface, but Commander Alford went down with the plane.

Crewmen of several nearby military vessels that were anchored in the area immediately launched boats and raced toward the scene. Butler was plucked from the water and rushed to Newport Naval Hospital, where he died shortly afterward. At one point, he commented that seaplanes should not be used for stunting.

Meanwhile, the search for the downed aircraft and the recovery of Commander Alford was underway. A few hours later, a navy tug brought the plane to the surface. Commander Alford was found still strapped in the cockpit. He had died from the crushing force of the impact and not from drowning.

Commander Alford had a distinguished naval career. During World War I, he earned the Navy Cross while commanding the destroyer USS *Nicholson*, and afterward he served in Washington, D.C. He was survived by his wife, Adelle.

THE MOST POPULAR COP CONTEST

In the spring of 1925, a newspaper called the *Cranston News* held a contest to see who was Cranston's most popular police officer. Citizens were asked to send in their ballots no later than April 10.

The response was overwhelming, with 334,000 votes cast. Not bad for a city that only had about 30,000 people at that time. The winner was Patrolman William H. Cooney, with 206,100 votes. Patrolman Jack McGee was the first runner-up with 84,700 votes, followed by Patrolman John Illingsworth with 35, 950 votes.

Patrolman Cooney was presented with a silver cup at the annual policeman's ball held at Rhodes on the Pawtuxet on April 16.

Votes had been cast by people from as far away as New York and Illinois, leading some to wonder how so many people even knew about Cranston in the first place. But it was all in good fun.

Perhaps the reason that Officer Cooney was so popular was because he liked to tell disparaging humorous stories about himself. One example was the time he was sent to break up a dice game on Dyer Avenue. As he was pedaling his bicycle at great speed to catch the ne'er-do-wells in the act, he suddenly realized that he had no brakes. As he came upon the game in progress, he was forced to go whizzing past in full view of the gamblers. He said that, as he went

past, he yelled, "If there are any of you rascals left when I get back, I'll run yez in!"

Officer Cooney was later promoted to sergeant. He died of a heart attack shortly after coming home from working the night shift in December 1939.

A POLICEMAN FOR OVER FIFTY YEARS

It has been said that police work is a job for a young person, and one wouldn't expect a man to still be at in his eighties, but one Cranston officer did just that. Clause Abramson was Cranston's oldest serving police officer and, most likely, the longest-serving policeman in the state, if not the entire country.

He joined the police department in 1907 as a special constable and was later appointed as a permanent patrolman in 1910, when Cranston incorporated as a city.

In those days, Officer Abramson got to his beat by riding a trolley and then walking foot patrol for the rest of his shift. Later, the city gave him a bicycle to use. As he gained seniority, he was offered a patrol car, but he declined, stating that he wanted to remain at his post, where he had come to know the people.

He remained a full-time patrolman until 1956. Afterward, he continued to work his beat as a special officer crossing schoolchildren. By all accounts, he was a very beloved and respected man. He remained at his post until he was well into his eighties, longer than any other police officer. Officer Abramson died quietly at home on November 27, 1965.

THE RHODE ISLAND AUTO LAW OF 1908

In March 1908, the Rhode Island General Assembly passed a new automobile law. One provision of the law took aim at standardizing speed limits from one town to the next. One must go fifteen miles per hour in a populated area, but he could zoom along at speeds of twenty-five miles per hour in the countryside.

All drivers had to be licensed. If one drove a car, the license fee was a dollar, but if one drove a motorcycle, it was only fifty cents.

Registration fees were based on the horsepower of the automobile's engine. Up to twenty horsepower was five dollars, between twenty and thirty horsepower was ten dollars, between thirty and forty was fifteen dollars and over forty was twenty dollars.

It was announced that new license plates would be issued after June 1, but the older plates would still be valid until they "wore out." Any motorist visiting the state would be required to register his automobile in Rhode Island after twenty days.

THE FIRST "AUTO POLICE"

Today, one takes it for granted that police officers will patrol their beats in a cruiser, yet there was a time when the very idea was considered preposterous.

In the early 1900s, automobiles were considered a luxury item for the wealthy and were thought of more as a novelty than a serious mode of transportation. They were mechanically unreliable, and road conditions of the day necessitated the need for numerous spare tires. Therefore, it was almost laughable when, in July 1910, it was proposed that the City of Cranston's police force be given a motor vehicle for patrol duty.

What astonished many throughout the state was that the idea was so readily accepted. Much larger cities, like Boston, Hartford and Providence, didn't allow the use of automobiles for their officers, yet here was Cranston, with barely twenty thousand inhabitants, going "high class." Thus, Cranston became the first police department in all of New England to own a police car.

Stranger still, the vehicle was donated to the department by one of its own officers, William H. Stone, who owned several cars and ran an ice business. It was said that he liked

being a policeman because it gave him something to do, not because of the $2.25 per day the city paid its officers to work a twelve-hour shift.

Cranston's first police car was a Ford Model-T. It was slow, lacked flashing lights and a siren, and the open passenger compartment exposed the officer to the elements. But it was considered a technological marvel for the era.

THE COP VERSUS THE YEGGMEN

Police work has changed drastically since the 1920s, yet there are times when it is exactly like in the movies. A case in point happened on Christmas Eve 1926, when a Cranston bluecoat went after some armed desperadoes.

The incident began when three men robbed two stores on Broad Street and made off with $810 in a stolen sedan bearing Massachusetts plates. A description was given to all officers to be on the lookout for the thugs and their car. About two hours later, Patrolman Michael Buzzard, who was at his post at Park and Wellington Avenues, saw the suspects drive past in their car. This was a time when police officers didn't carry portable radios, and communications broadcasts were done primarily through telephone call boxes. When Officer Buzzard saw the vehicle, he had to make a quick decision: run to a call box and report what he had seen or go after the bandits himself. He chose the latter and ran to his own personal car that was parked nearby.

He quickly caught up with the suspects near Reservoir Avenue, where he tried to take them into custody, but the bandits had no intentions of going quietly. They began shooting at the officer. Buzzard returned fire, emptying his gun as the stolen sedan sped away.

Undaunted, Buzzard resumed the pursuit in his own car, reloading with one hand and driving with the other. He caught up to the bandits again near Gansett Avenue, where the yeggmen once again began shooting. The bullets shattered Buzzard's windshield and punctured the fenders of his car, but fortunately none hit the officer. Buzzard fired back and struck the fleeing car several times.

As the chase wound its way up Cranston Street toward Providence, Buzzard kept hoping to see another foot patrolman so he could pick him up and have better odds in the gunfight, but none was to be seen.

The bandits entered Providence with Buzzard right behind, still trading shots with them. The chase wound its way through a series of back streets and eventually came out onto Broad Street in South Providence. By now, the officer was down to his last bullet. He slowed to hail a cabdriver and told him to call the Providence Police before resuming the chase. He came upon the suspect's vehicle at Taylor and Wesleyan Streets, but the yeggs were nowhere to be seen. Blood in the car indicated that at least one outlaw had been hit, but apparently not seriously.

Officer Buzzard received high praise for his efforts, but no medals, for back in those days, such valor was considered "part of the job."

ALWAYS LOOK BOTH WAYS

An interesting accident occurred along the Union Railroad trolley tracks on Woonasquatucket Avenue, in North Providence, on March 17, 1902. On that day, two small boys were standing along the tracks as a trolley approached. At the last second, one of the boys ran across the tracks. As he did so, he tripped and fell, but before he was run over, the fender of the trolley slid under his coat and picked him up. He was carried a short distance before the motorman could apply the brakes. He was not seriously injured.

DEFINITELY AN E-TICKET

Another unusual trolley accident occurred in Woonsocket on July 24, 1902. On that morning, Woonsocket Street Railway car number 1 was cresting the top of Globe Hill when the brakes failed. The car began freewheeling down the hill, gaining speed with each passing second. Sensing that a crash was imminent, a man named Proctor jumped. The other eight passengers onboard remained seated and held on until the car slowed to a stop a few hundred feet down the line.

Ironically, the only person injured was Mr. Proctor, who struck his head and was rendered unconscious.

A Close Call in Woonsocket

In the spring of 1919, the U.S. Army Air Service was looking to recruit new pilots. As part of that recruitment drive, "Air Circuses" were organized that would travel the country, making stops at local airfields to attract interest. These events attracted young and old alike and were advertised weeks in advance.

On June 12, 1919, a U.S. Army Curtis biplane took off from Mineola, Long Island, headed for New England, to take part in an air show. The pilot, Lieutenant R.C. Mofett, was an experienced flyer who had faith in both his abilities and his airplane. As he was passing over Rhode Island, he discovered he was low on fuel.

Airfields were few and far between in those days, and landing in just any open field carried risks. The landing gear could hit a rut, causing the plane to nose over, or a wing could dip and hit the ground, causing it to be torn away. The lieutenant's map showed that the nearest airfield was in Woonsocket, only a few miles from his location.

As the plane passed over North Smithfield to Woonsocket, its motor began to sputter, and the lieutenant desperately looked for a place to set down as he realized he would never make the airfield. Looking down, he spotted an open area known as Ronian's Field, near the present-day Mount St. Charles Academy. As the engine quit, he put the plane into a glide and aimed for the field.

As the air whistled through the struts, Mofett suddenly noticed a young girl sitting on a stone wall at the front end of the field. He could feel the plane dropping faster than he had expected and realized there was a good chance he might hit the wall where the girl was sitting.

Mofett shouted frantic warnings, and the girl looked up to see the airplane coming straight at her. There are many children, and adults alike, who would have sat frozen in terror at such a sight, but the girl was quick to react. Not a moment too soon, she rolled off the wall and landed on its opposite side, just as the landing gear crashed into the very spot where she had been sitting. With its landing gear torn away, the aircraft passed over her as she lay hugging the ground against the far side of the wall. As the fuselage struck the grassy field and plowed into the soft earth, Lieutenant Mofett suffered a gash to his head that required stitches, but otherwise he was alright. The little girl was lucky, too. She stood up, unharmed, and stared at a sight she would undoubtedly remember for the rest of her life and would one day relate to her grandchildren.

GOLD!

It is well known that the discovery of gold in California led to the famous Gold Rush of 1849, but how many are aware that gold was discovered in Rhode Island, too?

John A. Perry was one of those who went west with the other "Forty-niners" to seek his fortune. After spending

about five years searching for gold, he returned to Rhode Island, where he married Ellathea Harrington and moved to Foster. It was there that he discovered a piece of quartz that resembled the kind he had seen in California containing gold. After some preliminary testing that looked promising, John sent a sample to a company in Providence that confirmed the rock held a profitable content of gold.

John, along with his son Del, approached two prominent neighbors with their discovery, and together they formed the Homerstrike Mining Company in 1900. During the following year, they raised capital, bought machinery and built a mill for refining the metal.

Unfortunately, the whole operation went bust within a couple of years because the gold content proved too diverse from one sample to the next. Today, only a cellar hole stands where the mining company once thrived.

A "Bomb" Falls on Providence

On August 27, 1948, motorcycle patrolman A.F. Baribault of the Providence Police was cruising along Chestnut Street when he saw it drop. From his vantage point, he could see what looked like a bomb falling away from a navy fighter plane as it passed overhead. He could hardly believe his eyes as he watched it disappear behind some buildings and then saw flames shoot skyward. Was it possible, he wondered, that Providence had actually been bombed?

Lawrence Tabor saw it, too, and stared in amazement as he watched the cigar-shaped object crash to the ground at the intersection of Bassett and Ship Street, a mere one hundred yards from where he stood. He felt the concussion as it exploded and instinctively ducked as flaming liquid spewed in all directions.

Police and fire switchboards were flooded with calls of everything from a manhole explosion to a bomb attack. Officer Baribault quickly determined that the object was not a bomb, but was in fact an auxiliary fuel tank used by military fighter planes.

Droppable fuel tanks for military fighter aircraft had been developed during World War II to give the fighter escorts longer range when accompanying bomber aircraft on missions over enemy territory. The tank that dropped on Providence had come from a navy F6F Hellcat, based out of Quonset Point. The navy released a statement that the pilot had accidentally dropped the tank while on a routine flight and added that a formal inquiry into the incident would begin right away.

A "Hydroplane" Hits the Water

Nels J. Nelson was sixteen when the Wright brothers first flew in 1903, and like many others of the day who realized that mechanical flight was indeed possible, he set out to make his mark in aviation. He studied hard, learned to fly and, eight years later, he was building his own airplanes that were noted for their sturdy construction.

By 1913, he had developed what he called a "hydroplane," which was capable of taking off and landing in water, a novel idea for the time. The aircraft resembled a boat suspended under a set of wings.

On July 1, 1913, Nelson flew his hydroplane over Providence, where he circled the area of Exchange Place and city hall twice before making a turn around the dome of the state capitol. From there he flew south, where he landed in the water just offshore from the famous Rocky Point Amusement Park in Warwick. The purpose of his flight was to generate interest in an exhibition he was to give as part of the Fourth of July celebration festivities at Rocky Point.

Three demonstrations of his aircraft were scheduled. The first occurred without any problems, and Mr. Nelson landed to the roaring cheers of the crowd. On the second flight, Nelson took a twenty-one-year-old man as a passenger. The takeoff went smoothly, and the flight was uneventful until the aircraft was returning to land. As Mr. Nelson was making his final approach, he cut power to the engine in anticipation of gliding down to the water, but at that instant, a strong gust of wind caught the plane and sent it into a sharp turn downward into the bay.

As the spellbound crowds looked on, the plane dove into the water from an altitude of sixty feet. The passenger suffered a broken wrist, a laceration to his forehead and numerous bumps and bruises. Nelson was battered and dazed, but otherwise alright. Both men were rescued by the crew of a private boat that was anchored nearby, watching the festivities.

What became of Nelson's hydroplane isn't recorded, but the accident didn't deter him from further flying. The following September, he flew another plane that he had built from New Britain, Connecticut, to Chicago, Illinois.

A FOOTNOTE TO HISTORY

Sometimes minor events can have a cause-and-effect relationship on the future. For example, a young boy in Pennsylvania watches an airplane pass overhead and decides he wants to fly. A young man in Smithfield, Rhode Island, who shares the same passion for flying, builds an airport. The decision made by each would touch the life of the other, and one would go on to secure a place in history.

On the morning of December 22, 1934, a small open-cockpit U.S. Army biplane took off from Boston, headed for Pennsylvania. The pilot, Second Lieutenant William G. Benn, was part of the 103rd Observation Squadron of the Pennsylvania National Guard.

Snow flurries were falling as the plane left Boston. After a while, the flurries turned into a blinding snowstorm. Ice began forming on the plane's wings, which caused a loss of speed and altitude. Before long, the plane was barely above tree level and Lieutenant Benn knew he was in trouble. Some men might have decided to press on, mindful that it was close to Christmas and not wanting to be stranded somewhere far from home. However, good judgment told him that trying to push on under these conditions was

foolhardy. He knew he needed to set down and wait out the storm. The question was, where?

Checking his map, he noted an airport in Woonsocket, but that airport was now behind him. He reversed course, hoping to find it before he ran out of altitude. Suddenly, a small airport that wasn't on the map came into view. Deciding that this airport was as good as any, he set the plane down and coasted to a stop. He had no idea where he was, but it was good to be on the ground.

Lieutenant Benn had found the Smithfield Airport, constructed only a year earlier by John F. Emin Sr. John was an accomplished pilot who wanted to have a place to keep his airplane, a Curtis Pusher. As the lieutenant climbed out of the plane, John greeted him.

The lieutenant asked to use a telephone, but John explained that he didn't have one. The nearest phone was at a general store about a mile down the road, and John generously allowed him the use of his personal car to get to it. After alerting his superiors that he was safe, Lieutenant Benn returned to the Emin Farm, where he was invited to stay until the weather cleared.

Lieutenant Benn later enlisted in the Army Air Corps at the start of World War II. He was later promoted to major and was handpicked by General George Kenny to accompany him to the Pacific. It was there that Major Benn invented and perfected a new bombing technique called "skip bombing," which involved using bomber aircraft to skip a bomb across the water as one would skip a stone. The technique was highly successful against enemy shipping

and was credited with saving many American lives. For his efforts, Major Benn was awarded the Distinguished Service Cross by General Douglas MacArthur. The award is second only to the Medal of Honor.

Major Benn's success was featured in *Time* magazine on January 18, 1943. Unfortunately, he never saw the story. On the day the magazine hit the newsstands, he flew off on a mission and was never heard from again.

Like many who left home to fight in World War II, Major Benn's life was cut short, but his ingenious work saved many lives and helped to shorten the war. However, if he hadn't found the tiny airport in Smithfield on that snowy December morning, history may have turned out differently.

Why Did the Chicken Cross the Road?

In April 1930, the Rhode Island Senate passed a bill that made it illegal to transport chickens (that's right, chickens) between 9:00 p.m. and 5:00 a.m. unless written permission was first obtained from the Department of Agriculture. Apparently, the elected officials felt the issue of overnight chicken hauling had reached a level at which the problem needed quick and decisive action to rid the roads of this menace.

A Conflagration in Tiverton

Perhaps the worst disaster to occur in Tiverton was the massive fire that destroyed the New England Terminal Company on November 1, 1933.

The incident began with the installation of a new eighty-thousand-gallon oil tank. After construction was complete, workmen pumped the tank full of seawater to check for any leakage and to test the tank's structural integrity. As the tank filled with water, three men climbed to the top to check the upper seals. As the water neared the top, the whole structure suddenly collapsed without warning.

The wreckage fell onto a pump house that contained electric motors. The resulting short circuit ignited a nearby fuel oil tank. Before that fire could be brought under control, the flames had spread to two larger fuel tanks. The intense heat generated by the flames caused two massive gasoline storage tanks to explode, which sent flaming debris hundreds of feet in all directions. Tiverton Chief of Police George Potter later reported seeing a man making his way between the two tanks just before the explosion.

The massive pillar of oily black smoke rose thousands of feet into the air and could be seen for miles. That evening, the orange glow from the conflagration was seen far out to sea. Special railroad cars loaded with firefighting chemicals used specifically for oil fires were sent from Fall River to assist in battling the blaze. Nearby residents were forced to

evacuate, and some spent the next two nights sheltered in a schoolhouse.

The flames burned for more than forty-eight hours before they were brought under control. When it was over, three workmen were confirmed dead, several others were seriously injured and one man was reported missing. Several buildings were destroyed and two homes were damaged. Monetary losses were estimated to be at $1,000,000.

The incident caused some legislators to reevaluate the state's fire prevention laws regarding oil-storage tanks.

A Revolutionary War Hero's Remains

It only takes one generation for memory to fade and knowledge to become lost. With the further passage of time, knowledge gets replaced with rumor and folklore, and facts become murky. Such was the case with the final resting place of General Nathanael Greene, Rhode Island's best-known Revolutionary War hero. After his death in 1786, the place of his interment was quickly forgotten, and the mystery of its location endured until a Rhode Island man solved it in 1901.

General Greene was born in Warwick in 1742. He was known as a brilliant strategist and was one of only three generals in the Continental army to serve for the entire Revolutionary War. After the war, he settled on an estate fourteen miles north of Savannah, Georgia, called

Mulberry Grove. He died there at the age of forty-four, and his body was placed in a crypt marked "Jones" in Colonial Cemetery in Savannah. Why he was interred in that crypt is unclear at this time.

It wasn't long before the facts surrounding the burial were forgotten. Locals often pointed to several other crypts that were rumored to hold the general's remains. Some claimed he was interred in a crypt that was located in an entirely different cemetery. One story told that the general's body had been removed from the crypt by slaves acting on orders from the man whose estate Greene had confiscated during the war because of his British loyalties. It was said that the slaves threw his remains into the Savannah River, where they would never be found.

As early as 1820, the City of Savannah appointed a committee to uncover the truth and locate the general's final resting place, but they were unable to do so.

In early 1901, a man named Colonel Asa Bird Gardiner set out from Rhode Island to solve the mystery. Acting on some historical records surrounding the burial, he went to Savannah, and after obtaining the proper permissions, he went to Colonial Cemetery and began checking the crypts suspected of holding the general's remains. After checking several crypts, he came to one marked "Jones" that had been bricked up. Workmen broke through the bricks and entered the tomb. Inside they found three crumbling caskets with silver nameplates. The first casket contained the remains of a man who died in 1845. The second contained the remains of General Greene,

and the third contained the remains of his son, George Washington Greene, who died in 1793. Mr. Gardiner's research indicated that General Greene had been buried in his uniform, and several brass military buttons were found among the general's remains.

The bones of General Greene and his son were carefully placed in boxes and taken to the local police station for safekeeping. The following day, they were put in sealed caskets and placed in a bank vault until it could be determined if they should be returned to Rhode Island or buried locally. It was finally decided that they should remain in Savannah, and they were buried in Johnson Square. Thanks to Mr. Gardiner, the final resting place of Rhode Island's famous war hero won't be forgotten again.

THE LAND SWAP PROPOSAL OF 1894

There was a time when the boundary line between Massachusetts and Rhode Island was in dispute, with both states laying claim to the same land. However, by the late 1800s, all disputes had been settled more or less to everyone's satisfaction. Then, in December 1894, a proposal to swap land in Rhode Island for some land in Massachusetts was put forth. It seemed like a good idea at the time.

It all began when a man named James Potter wanted to build a large manufacturing plant on land that straddled the boundary line of both Pawtucket, Rhode Island,

and Attleborough, Massachusetts. The site was ideal for the sprawling complex of mill buildings that he planned to construct. Unfortunately, there were some logistical problems with building at that location.

The first was the lack of water supply in Attleborough. The City of Pawtucket had city water, but the portion of Attleborough where the land was located did not, and Pawtucket was not inclined to run pipes into Massachusetts. The next was electrical power: Pawtucket had it, and Attleborough did not.

Another concern was the jurisdictional issues that could arise if a fire broke out in one of the mills. Firemen from either community would be prohibited from crossing state lines. In addition, any potential court proceedings could hinge on exactly which room of a particular building an incident was said to have happened in. Permit applications would be redundant, and municipal regulations between two jurisdictions could be chaotic. Finally, there was the tax issue. Attleborough's taxes were higher than Pawtucket's.

Therefore, an idea was put forth to swap the land in Attleborough for land in Tiverton. The land in Attleborough would go to Pawtucket, and the Village of North Tiverton would go to Fall River. The people of Attleborough were in favor of the deal, as the impact on tax revenue would be minimal, and the manufacturing jobs that would be created would benefit the town. Those in Pawtucket and Fall River were naturally in favor of acquiring more land, but there was a catch. Apparently, nobody had asked the residents of Tiverton what they thought of the idea.

The Village of North Tiverton was, and still is, the most developed area of the town. In the 1890s, it was a popular weekend destination for those in Fall River. Therefore, its annexation would mean a loss in both tax revenue and business income. So it is understandable that the citizens of Tiverton were opposed to the idea.

Thus, the deal never took place, and it was the last time anyone in Rhode Island suggested swapping land with Massachusetts.

THE SLOOP *COLUMBIA*

At one time, Newport was well known for the America's Cup yacht races, where wealthy competitors vied for the coveted America's Cup Trophy. One of the most legendary boats to compete was the sloop *Columbia*, the first boat to win the cup twice in a row. Yet for all its success, very few people know that it had an ominous beginning.

The *Columbia* was built in 1898–99 at the Herreshoff Manufacturing Company in Bristol, Rhode Island, for the famous J. Pierpont Morgan and Edwin D. Morgan of New York City. No expense was spared. It was 131 feet long from stem to stern and 24 feet at the widest point. Its hull consisted of Tobin bronze over a nickel steel framework, with lead ballast in its hold. It was perhaps the finest ship in its class for the day.

Its launching took place in the evening of June 10, 1899, in view of six thousand spectators who had come from all over to witness the event. After the traditional christening

of champagne across its bow, the *Columbia* began its controlled slide down the rails and into the bay. It was then that disaster struck. An eager photographer, who wanted to be sure of capturing the moment in the fading light, overloaded his flash pan with magnesium. When he set off the charge, there was a terrific explosion. A ten-year-old boy standing next to him was killed, and seven others were severely injured. Remarkably, due to the size of the crowd, the incident went unnoticed by many, who only learned of it the following day in the newspapers.

Despite what some would consider a bad omen, the *Columbia* went on to win the America's Cup Trophy that year and again in 1901. In 1903, it was beaten in sea trials by newer and faster boats, thus ending its short but illustrious career.

Unfortunately, the *Columbia* was designed and built for one thing—to win races. Operating and maintaining such a boat for pleasure purposes was extremely cost prohibitive. Therefore, it was sold for scrap in 1913 and faded into yachting history.

PEGASUS DISGUISED AS NORWICH

The following story seems to support the old adage "If it seems too good to be true, then it probably is."

Edmond F. Descy was a successful Woonsocket businessman. On Friday, June 17, 1921, an acquaintance suggested that Descy take the day off and accompany him to Newport, which Descy did. At one point, the two men were walking through Touro Park, near the famous "Newport Tower," when the acquaintance suddenly spied a man's wallet lying on the grass. Inside were several thousand dollars, a calling card identifying the owner and a receipt for a nearby hotel.

They went to the hotel and found the owner registered there. The man was so pleased to get his wallet back that he insisted on giving Mr. Descy and his acquaintance five hundred dollars each as a reward. He then "confidentially" revealed to them that he was about to go to a "private" horse betting parlor because he had a "hot tip" on a particular horse that was guaranteed to win the race. The horse in question was the famous Pegasus, but Pegasus was running under the alias of "Norwich," and at long odds. Those betting on Norwich were certain to make a lot of

money. Then, to further show his appreciation, he offered to allow the men to accompany him to the betting parlor.

Mr. Descy and his friend accepted the offer, and the man drove them to a plain-looking cottage in Middletown. The inside however was lavishly furnished, with fine artwork hanging on the walls, heavy drapes and plush carpeting. The three men placed their bets on Norwich, and the horse won. The winnings owed to Mr. Descy and his friend came to $288,000. Unfortunately, the men were told, the parlor didn't have that kind of cash on hand. If they came back on Monday, they would be paid in full. In the meantime, it was suggested that they leave behind a portion of their own money "to show their good faith." Mr. Descy was no fool and recognized a scam when he saw one. The men at the parlor were rather insistent, so he offered them a check, but they refused. He was finally allowed to leave after promising to return with $20,000 in cash.

Back in Woonsocket, Mr. Descy went to the police station and told his story. On Monday, he returned to Newport accompanied by two Woonsocket detectives. At the Newport police station, they were joined by Newport's chief of police and six of his burliest officers. When they arrived at the cottage in Middletown, all they found was an empty house. All of the elaborate furnishings, carpets and drapes had been removed, and nothing remained except a few wires hanging on the walls.

The police suspected the gang of hucksters was the same one that had been operating elaborate scams in the state for the last few months. As for Mr. Descy, he was rather amused by the whole affair.

NEWPORT IS SHELLED BY "FRIENDLY FIRE"

On July 25, 1901, the U.S. Navy battleship *Kearsarge* was on maneuvers off the coast of Newport. It was a new ship, commissioned only seventeen months earlier in Virginia, and was destined to become the flagship of the North Atlantic Fleet.

At five o'clock that evening, the ship's company was called to "general quarters" for a gunnery drill. Normally, practice drills would be conducted with "dummy" ammunition, but somehow a live shell came to be loaded in a deck gun and was fired. The trajectory of the gun sent the shell sailing toward Newport.

The discharge of the gun sent ship officers scrambling to find out what had happened. The gun crew claimed the shell fell short and landed in the water, but this was unconfirmed. Other reports said it had landed squarely in downtown Newport.

The navy had to be sure, so two officers set out from the *Kearsarge* in a small boat, following the path of the shell. When they came ashore, they learned that the shell had, in fact, reached the city, and furthermore, it had exploded right in front of Newport City Hall. Steel shell fragments still littered the area, and the two navy men no doubt had to endure some glaring looks from the local populace. Fortunately, there were no injuries, which is remarkable considering the streets were clogged with people at the

time. Damage was confined to a severed tree limb, and a chunk of stone missing from city hall.

DOLPHIN HUNTING OFF BLOCK ISLAND

Dolphins are seldom, if ever, seen in Rhode Island waters today. But in 1895, they were apparently plentiful, as evidenced by some Block Island boat owners who chartered their boats to "city people" to hunt for them. The word "hunt" is an accurate term, as the "sportsmen" didn't attempt to land the large mammals with a fishing pole and line, but instead with a rifle.

There were those who liked dolphins for their meat and disliked them for the sea bass, bluefish and mackerel that they ate. They hunted the creatures for food and population control. However, there were others from the mainland who liked to hunt them for "sport."

Although hunting dolphins hardly seems like sport, the reader may be interested to know that the dolphins were in fact hard to shoot, especially if the boat captain positioned the craft in such a way that it would bob across the waves. This gave the shooter an unsteady platform from which to fire, and since both the shooter and the target were moving at the same time, actually hitting a dolphin became more of a stroke of luck rather than skill. Thus, the outing was similar to a carnival game, for it can be surmised that some of the boat captains had no desire to actually deplete the dolphin population to the point where it would eliminate a valuable source of revenue.

THE GOAT ISLAND TORPEDO STATION

Goat Island is located in Newport Harbor and today is the site of a luxury hotel and resort. But long before the hotel was built, the island was the site of a U.S. Navy torpedo station, where modern torpedo weaponry was first developed.

The torpedo station was established in 1869, and the technology developed there no doubt helped America win sea battles, shorten wars and save lives. But such development came with a price that is all but forgotten today.

On August 29, 1881, two naval officers were killed when a torpedo they were testing exploded without warning. The incident began shortly before two o'clock, when Lieutenant Commander Benjamin Edes and Lieutenant Lyman Spalding took a boat a short distance from shore, carrying a torpedo. They set the torpedo in the water, attached a pair of electrical wires to the war head and went back to shore. The wires were then connected to a detonating device, but when the plunger was activated, the torpedo failed to explode. Those onshore felt a leaky seal on the torpedo was to blame, so a superior officer ordered Edes and Spalding to prepare another torpedo. As the two men reached the supposed "dud" torpedo, it exploded, sending a huge geyser of water skyward. Both men were killed instantly, but they were not the only fatalities at the station.

On July 4, 1893, a fire broke out in a guncotton factory on the island and nearly one hundred men gathered around

the building to fight the fire. As a group of men were playing hoses on the eastern side, a massive explosion blew the entire wall outward directly into the group, scattering the men like bowling pins. Three men were killed instantly; eight others were severely injured.

Another horrific tragedy occurred in January 1918, when thirteen men were killed and ten others were injured in an explosion at a torpedo assembly area.

The torpedo station closed in the 1950s. Thousands of people visit Goat Island every year, totally unaware that the peaceful, idyllic setting has a darker past.

IZZY AND MOE COME TO RHODE ISLAND

The Roaring Twenties are also known as the Prohibition Era, when the words "speakeasy," "bathtub gin" and "near beer" were part of everyone's vocabulary. Two of the best-known Prohibition agents to work for the federal government were Izzy Einstein and Moe Smith, who racked up nearly five thousand arrests for violation of the Volstead Act. Their success was owed to the fact that they didn't look like typical federal agents. In fact, they often wore theatrical disguises and costumes in order to gain the confidence of bartenders and saloon keepers. Their colorful careers were even depicted in a Hollywood movie in 1985.

On September 7, 1922, the duo came to Rhode Island from New York, and with the help of other agents, raided

several establishments. The reception they received was less than respectful compared with other areas of the country in which they had operated. Saloon keepers simply laughed when served a summons to appear in front of the United States commissioner of Prohibition. In one instance, an irate bartender threw a pitcher of whiskey in Izzy's face. All made it clear that they planned to ignore any legal proceedings brought against them. But the biggest insult came on September 9, when they were both arrested by sheriff's deputies at the office of the United States commissioner in Providence.

The arrests were the result of a civil complaint filed in Providence Superior Court by a Central Falls bar owner, who alleged that he had been assaulted by Einstein and Smith. A third agent was charged with trespassing. The complainant was suing for $25,000, which was an astronomical sum in those days.

When news of the arrests reached Prohibition Commissioner Haynes in Washington, D.C., a team of lawyers was dispatched to Rhode Island to defend the agents. The government even considered legal action against the sheriff's deputies. Smith and the other agent were released under their own recognizance, while Einstein was released under $10,000 bail.

Back in New York, Izzy Einstein described Providence as being a "wide open" town that was worse than New York ever was in its disregard for the Prohibition law!

DON'T TRY THIS AT HOME

A favorite Fourth of July prank often played by the youngsters of yesteryear involved placing a mixture of potash and sulfur on railroad tracks. This noisy practice, though inventive and fun, could also bring about some unexpected results. The powdery mixture would be folded in newspaper and laid on top of the rail. Then, when a train or a trolley happened past, the heat of the wheels, along with the weight of the vehicle, would cause the powder to ignite. The result was generally a bright flash and a loud bang. When small amounts of the mixture were placed on the tracks, this practice usually resulted in nothing more serious than startled passengers. However, there were occasions when the little miscreants would get carried away and add a little too much powder.

Such was the case in the Apponaug section of Warwick on June 30, 1910, when some little ne'er-do-wells decided to start their Fourth of July celebrations early. After placing a substantial amount of powder on some trolley tracks, they loitered in the shade of a tree to see what would develop. It wasn't long before a trolley came past, carrying about a half dozen passengers. When the powder ignited, the resulting explosion lifted the front of the car a good fifteen inches into the air. By some miracle, the trolley's wheels happened to land squarely back on the tracks, and there was no derailment; however, the air brakes were damaged.

The passengers were badly shaken, but no serious injuries were reported. No doubt the motorman dearly wanted to have some meaningful dialogue with the little urchins responsible.

THE SKELETON IN THE ORCHARD

On January 31, 1906, William Vanner was removing stones from an apple orchard in the Thornton section of Johnston, when he made a grizzly find. He came upon a pile of stones stuffed between two boulders, and while removing some of the gray granite rocks, he grabbed one that seemed unusually white and smooth. Closer examination revealed that he had picked up a human skull!

Word of the find spread quickly, and before long a few dozen people had gathered at the orchard to see for themselves what all the excitement was about. Doctor

Shaw, the town physician, examined the bones and told Chief of Police Kimball that they belonged to a man under thirty years of age who had suffered a broken collarbone at the time of his death. Any clothing, like the rest of the remains, had long since disintegrated, and only buckles and buttons

remained, but the feet were still clad in a pair of leather shoes. There was nothing to indicate the man's identity.

It was Dr. Shaw's opinion that the man had been murdered and the body placed under the rocks to conceal the crime. The only clue to the mystery was the discovery of three coins next to the bones. The newest one was dated 1893.

A Record Trip in a Balloon

On the morning of July 21, 1910, a large hot air balloon landed on the farm of Jenckes E. Mowry in Burrillville. Balloon landings on farms were not a common occurrence, and what made this one even more remarkable was that this particular balloon had taken off from Philadelphia, Pennsylvania, only twelve hours and five minutes earlier.

The famous aeronaut Dr. Thomas E. Eldridge was at the controls. Accompanying him were his son Arthur and a colleague, Fred Underhill. They left Philadelphia at ten o'clock the previous night and were carried northeast by the prevailing winds. After crossing Connecticut, they passed over the Wallum Lake Sanatorium, where they could clearly hear the voices of those on the ground. Then the wind began to take them southeast, and when they saw water in the distance, they feared they may be nearing the ocean so they decided to set down. They had traveled a total of 301 miles, which even today is considered a great distance for a balloon.

The aeronauts were greeted by throngs of people who had been following the progress of the balloon as it descended

across Burrillville. Those with cameras were allowed to take photographs. Perhaps some of these pictures are still in existence, tucked away in dusty photo albums, waiting to be rediscovered.

The Road to Redemption

This story illustrates that just as a caterpillar can shed its former self and become a butterfly, a man can come to realize the error of his ways and make amends.

In the early morning hours of November 4, 1948, five men broke into the Green Hill Spa on Providence Street in West Warwick. It was not a random act, but a well-calculated plan. Their intent was to cut a hole in the ceiling of the spa to gain entry into the Knightsville Loan Corporation's office, located on the second floor. The loan office was known to have a safe that contained a large sum of cash. Everything was going smoothly until the owner of the spa unexpectedly showed up at 1:25 a.m. and scared the would-be burglars off.

Police were notified and arrested three of the men within twenty-four hours. Two of the three were convicted and received deferred sentences. The third had his case dismissed. A forth man was arrested seven years later in March 1955, and he, too, received a deferred sentence. The fifth man had fled to California and managed to elude authorities for almost thirteen years. Then he won the lottery.

On March 25, 1961, the fifth man won $140,000 in the Irish Sweepstakes. After taxes and other fees, he was left with

$48,000, which was a substantial sum in those days. Feeling he should share his good fortune, he and his wife traveled back to West Warwick and began to donate some of the money to charities of their choice. They gave $2,000 to the Sacred Heart Church of Natick, and another $1,500 to St. Bartholomew's Church in Providence. Word spread fast, and before they could give away any more money, the man was arrested for the 1948 breaking and entering charge. He was brought before the court, where he expressed remorse for what he had done and pled nolo contendere to the charges. The judge, after taking everything into consideration, gave him a deferred sentence and allowed him to go free. It was said that he and his wife planned to take a trip to England.

A YOUNG MAN'S ACT OF BRAVERY

December 20, 1909, was a beautiful winter's day, and eight-year-old Robert Wood went out to enjoy a carriage ride with his grandfather in West Warwick. At the end of the ride, the grandfather stopped the vehicle on Pike Street and got out. Since it was Robert's birthday, he was allowed to take the carriage around the corner by himself to be put away. As he headed up Pike Street, the horse suddenly began to pick up speed and took off on his own volition. Young Robert quickly lost control of the situation as the horse ran away with the carriage. When the horse abruptly turned onto East Main Street, Robert fell from the seat and landed on the floorboards, where he was in danger of falling from the

rocking vehicle. Those witnessing the event, not knowing what to do, stood by, horrified. A runaway horse weighing hundreds of pounds was dangerous enough, but even more so when the animal was hauling a carriage behind it.

One witness was thirteen-year-old Everett Roberts Jr., who had been visiting Kinsley's store on East Main Street. With total disregard for his own personal safety, he ran after the runaway carriage and managed to jump onto the rear of it and climb aboard. Once he was able to grab hold of the reins, he brought the frightened horse to a stop. Needless to say, young Robert was extremely grateful to know that he would live to see another birthday.

"SUBTERRANEAN EXCAVATIONAL ENGINEERS"

Many a World War II war movie has depicted prisoners of war who attempt to tunnel their way to freedom. Most of these movies are based on actual events. One may be surprised to learn that in 1938, before World War II, such an event took place at the state prison in Cranston.

Which of the inmates involved in the scheme came up with the idea of a tunnel is unknown, but all six were assigned to work in a building where they made cement curbstones for the state Department of Transportation. The building was located in the prison yard about forty-five feet from the wall.

The tunnel was begun around the middle of February, when the men used hammers and chisels to break through

the concrete floor of the building. They hid the tunnel entrance by sliding a pile of wooden pallets over it. The dirt and sand removed from the hole were mixed with the dirt and sand mixture constantly delivered to the shop to be used in the making of cement for the curbstones. When the mixture was sifted, the sand was used for the cement and the dirt was removed and dumped outside.

After digging a shaft ten feet deep, the men began tunneling toward the prison wall. They worked steadily throughout the spring and summer, and by September they had progressed thirty-five feet. Things were going well until the day corrections officers discovered the tunnel while making a routine inspection. All six of the inmates were immediately placed in solitary confinement.

It was estimated that the tunnel would have been finished by November, which caused officials to wonder why one of the inmates involved took part in the plan as he was scheduled for release at that time.

The tunnel was reportedly filled in with concrete. As far as it is known, this was the only time an escape attempt from the prison was made by digging a tunnel. No doubt, those who worked in the building afterward were better supervised.

THE WILD BLUE

It must have been exciting to be a young fighter-pilot-in-training in the early days of World War II. Imagine being able

to fly the most powerful fighter aircraft of the day while barely out of your teens! While most trainees accepted this awesome responsibility with proper reverence, there were a few who put their youthful exuberance in front of military regulations and attempted unauthorized maneuvers. Such was the case in November 1942, when a pretty East Greenwich woman was forced the throw herself to the ground as a fighter plane swooped out of the sky and barely missed hitting her house. Several other such incidents prompted the East Greenwich Town Council to draft a letter to the military training bases at Hillsgrove, Charlestown and Quonset, requesting that the practice be stopped.

HE COULD RUN, BUT HE COULDN'T HIDE

It has been said that the Northwest Mounties always get their man. The same could be said of a Providence housewife who single-handedly captured her deadbeat husband in August 1900.

She and her husband had been married for twelve years and had four children. Without warning, he left her, and she filed charges against him for nonsupport. Before police could apprehend him, the man fled to New York. Since he had fled the jurisdiction of the court, Rhode Island police were powerless do anything more, as nonsupport was not an extraditable offense. Since local officials could do nothing, the wife decided to take matters into her own hands and extradite the man herself.

She booked passage to New York and managed to find her husband. She told him that all was forgiven and mentioned that she now owned a successful store in Rhode Island and wanted him to come back and run it. The man agreed to return to Rhode Island with her, and as soon as he stepped off the boat in Providence, he was arrested. Standing before the judge, the man agreed to pay the sum of five dollars a week to the woman.

NASTY NEIGHBORS

Sarah and Mary both lived in the same tenement house in Providence, but an ongoing feud existed between the two. What started it is unknown, but it came to a head one hot afternoon in August 1900, and the case wound up in court.

The incident began when Mary hung some wash out to dry on the clothesline. Seeing this, Sarah thought it would be a good time to take her rugs outside and beat the dirt out of them. Of course, the dirt was landing on Mary's wet clothes, which elicited a predictable reaction from Mary. Sarah, pleased with the result, refused to cease what she was doing. Mary then took an ordinary garden hose and turned it on the rugs to wet them down in order to prevent the dusty dirt from being expelled into the air. While doing so, some of the water "accidentally" spattered in Sarah's face, causing her to call the police and press charges for assault.

The case went to Sixth District Court in September. The judge agreed that an assault had taken place, but added that

he could see where Mary had "considerable provocation." He found Mary guilty, but only fined her one cent.

HANGING BY A THREAD

Shortly after noontime on December 7, 1900, two eleven-year-old boys were playing on the railroad bridge that spanned the Blackstone River near River Street in Woonsocket, when one of them slipped and fell between the ties. Normally in such cases, death would have been certain, but fortunately for the lad, the sleeve of his woolen coat snagged on a support beam and held him suspended in the air, dangling over the cold, rushing water below. There was nothing his companion could do but run for help.

All the hapless boy could do was to try not to struggle lest his coat come loose from its hook. But as the seconds ticked away, the sleeve of the coat began to rip at the seams. Desperately looking around, the boy saw Timothy Owens walking along River Street and called for help. Mr. Owens heard the cries and ran to the bridge. He grabbed hold of the boy just in the nick of time, saving him from a watery grave.

TWO CHIEFS OF POLICE

Following local politics has long been a spectator sport in Rhode Island because it can be so interesting. Take, for

example, the following story in which the City of Newport was left with two chiefs of police.

The situation began in January 1900, when Pardon S. Kaull was elected to the position of chief by the Newport City Council. Five months later, in May of that year, the Rhode Island General Assembly passed an act to establish a board of police commissioners for Newport. The act allowed the governor, with consent from the state senate, to appoint three commissioners, who would have the authority to, among other things, remove or appoint a chief of police. Why this was done is unclear, but the newly formed commission appointed its own designee, Benjamin H. Richards, to head the department. When Chief Richards arrived at the police station for his first day at work on June 19, he found Chief Kaull sitting in the chief's office.

What transpired between the two is not recorded, but for the time being, Newport was left with two police chiefs, which no doubt left the rank and file officers wondering from whom they were to take orders.

Chief Kaull sent a letter to Senator Jeremiah W. Horton, the head of the Newport Police Commission, basically stating that he believed that the law creating the police commission was unconstitutional. He added that he had been duly elected by the city council and therefore had no plans to vacate his position. The police commission responded by contacting the Newport County Sheriff's Office and having the chief escorted from the station. This was what Chief Kaull wanted, for it allowed him to file a lawsuit, which he could not have done if he had left on his

own. He then sued the commission for his salary and to test the law's constitutionality. Unfortunately for Chief Kaull, the Rhode Island Supreme Court ruled against him and found the creation of the Newport Police Commission to be constitutional.

THE ACCIDENTAL HORSE THIEF

Just how does one "accidentally" steal a horse? That's the question the police wanted answered and a befuddled lawyer was left to explain.

The incident happened in Woonsocket on June 12, 1900, when a local lawyer went to the Union Livery Stable about 3:00 p.m. and rented a horse and carriage for a trip to Pawtucket. On the way, he stopped at Simmons Drug Store and left the carriage parked outside. While he was in the store, a highway cleaning crew came along and moved the rented rig to the other side of the street. Shortly afterward, a man named Paine drove up to the drugstore in a similar carriage and parked it exactly where the lawyer had left his rental. Mr. Paine then went into a nearby store. The lawyer emerged from the drugstore, inadvertently got into Mr. Paine's carriage and drove off. When Mr. Paine returned and discovered his ride missing, he promptly notified the police, who wired a message to surrounding jurisdictions to be on the watch for the stolen vehicle.

In the meantime, the lawyer innocently drove to Pawtucket and completed his business, all the while unaware that, should a sharp-eyed officer spot the stolen carriage, he would be arrested. He returned to the livery stable at 11:00 p.m. and was told he was driving a different carriage than the one he had left with. The lawyer was at a loss to explain how such a thing could have happened. He left the carriage at the stable and went directly to the Woonsocket police station. Fortunately, a Woonsocket officer had noticed a rig standing unattended for several hours across from Simmons Drug Store and put two and two together. When the lawyer arrived at the police station, the situation was quickly rectified to everyone's satisfaction.

Imagine the Possibilities

In May 1900, Abraham Mowry, a chicken farmer in Smithfield, was surprised to see a newly hatched chick with four legs. He brought the curiosity to Kingston, where it could be studied for possible breeding. Imagine,

a chicken with four drumsticks! Such a thing would have made Mr. Mowry a very rich man. But alas, it was not be, and today farmers are still breeding chickens with the traditional two legs.

A LETHAL INVENTION

During World War II, many states had state guard reserve units, created by an act of Congress in October 1940, to fill the void created when National Guard troops were called for federal service two months earlier. These quasi military units were responsible for a variety of tasks relating to home defense. During the war, two officers of the Fifth Provisional Company of Glocester distinguished themselves by inventing a gun that they termed a "scatter cannon."

The cannon's inventors, Captain Leslie E. Davis and Lieutenant Loren W. King, felt that troops stationed at roadblocks needed something a little more powerful than homemade hand grenades and shotguns; something that could effectively stop a moving vehicle.

The device was simple, yet effective. Basically, it was made of a three-foot piece of common black iron pipe, capped at one end and mounted on a tripod. The gun was also equipped with a pistol grip and aiming device. It was easy to build as the materials could be found at any hardware store.

The "grapeshot" fired by the cannon consisted of everyday nuts and bolts that, when test fired at a tactical

school in Sturbridge, Massachusetts, tore through an old army truck like it was paper. The cannon was also capable of launching a Molotov Cocktail and a homemade rocket shell consisting of three sticks of dynamite.

Plans and diagrams for the invention were published in several state guard manuals across the country, enabling units in other states to build cannons of their own. Exactly how many scatter cannons were actually produced is unknown. Nor is it known if any were used in hostile action. However, the fact that the device was invented is a credit to American ingenuity.

The Fifth Provisional Company was disbanded after the war on January 19, 1946.

THE ICE BOAT OF WALLUM LAKE

On the shores of Wallum Lake in Burrillville, in the extreme northwest corner of Rhode Island, is a cluster of buildings that were part of the Wallum Lake Sanatorium, a state-run hospital where those with tuberculosis were once treated. It gets cold there in the winter. The lake freezes, and some say the area gets more than its share of snow. Perhaps it was the difficulty in getting around in the winter that inspired Henry Wemett, an employee at the sanatorium, to invent his incredible ice boat in 1946.

Henry worked as an engineer at the sanatorium's power plant during World War II. When gas rationing went into effect, he purchased a secondhand motorcycle to get

around. After the war, when gas became plentiful again, he went back to driving his car and put the motorcycle in his garage. There it would most likely have sat if Henry hadn't come up with the idea of his ice boat.

Working in his spare time, Henry began building a fifteen-foot-long, two-seater vehicle, capable of carrying him and a passenger across the frozen ice of Wallum Lake. It consisted of a light frame covered with canvas, which rested on three metal runners that resembled skis. The front runner was used for steering, while the rear two provided balance. Henry used the engine from his trusty wartime motorcycle to power the sleek-looking craft. The engine delivered torque to a single automobile tire between the two rear runners that was equipped with forty-eight steel spikes for traction. He dubbed his invention an "ice boat," even though it was never intended to sit in water.

The day finally came in January 1946, when the ice boat was ready for its maiden voyage. The craft shot out across the frozen lake and reached speeds of sixty miles per hour. Those viewing the spectacle from shore cheered and waved as Henry maneuvered the craft around the ice as easily as any automobile. Back onshore, it was discovered that the craft handled just as well on land and could negotiate the snow-covered highways with ease.

The only mishap recorded with the craft occurred one day when Henry applied the brakes while skimming across the ice at high speed just to see what would happen. The boat went into a spin and finally flipped on its side, causing minor damage but no injuries to Henry.

What became of Henry Wemett's ice boat is unknown. Today, with snowmobiles in common use, one may think that Henry's idea was nothing new. However, the story takes on more significance when one realizes that the first commercial snowmobiles didn't come on the market until the late 1950s.

A BEAR MENACES JOHNSTON

It is hard to imagine a time when bears were a problem in Rhode Island, but such was the case in the nineteenth century. One such incident involved a black bear that was purchased at auction by a tavern owner and kept in a cage. Shortly before Christmas 1858, the bear escaped and made his way into the countryside.

The first to encounter the bear was a farmer who went to his barn to get a horse. The bear had taken refuge inside and wasn't at all happy about being roused from his slumber. The farmer barely escaped being mauled by running through a side door.

The bear later climbed a tree that hung over a turnpike road and panicked a team of horses pulling a stagecoach. The horses took off at full gallop, and it was all the driver could do to keep them from wrecking the stage.

Afterward, the bear made his way to the home of Mr. Littlefield and looked in the kitchen window. There he saw the lady of the house fixing a meal, the smell of which was no doubt irresistible to the hungry bruin. The bear forced his way through the window, much to the terror of Mrs.

Littlefield, who went screaming for her husband. In short order, Mr. Littlefield appeared and dispatched the hapless bruin to the land of milk and honey with five slugs from his rifle.

How Much Was It Worth?

In September 1908, a New York socialite, who was spending the summer in Newport, was out for a leisurely carriage ride along Bellevue Avenue. It was a pleasant summer day, and although late in the season, it was still important to be seen by the right people as one passed the famous "summer cottages" of the super rich. The woman herself lived in one of those "cottages" and had an image to uphold.

Suddenly, without warning, her horse became spooked and took off at a full gallop. Despite stern commands and pulling on the reins by the socialite, the horse refused to slow down, and the woman found herself in a serious predicament that could possibly end in disaster. Fortunately, Patrolman Maurice Crane of the Newport Police was walking his post on Bellevue Avenue and saw what was happening. At great risk to himself, he quickly ran out into the street, and in a scene reminiscent of an old-time western movie, managed to stop the runaway horse.

Like anything that happened to or in Newport Society in those days, word of the event spread quickly, and the socialite told more than one person that she felt the officer had saved her life.

Approximately one month later, Officer Crane was approached by a well-dressed coachman employed by the socialite and given a crisp one dollar bill as a reward for saving the woman's life.

A Frightful Day at Beavertail Light

Beavertail Light is a well-known landmark in Rhode Island and a popular destination for tourists and residents alike. Visitors have trekked to the rocky shores near the light for fun and fishing for well over a hundred years. So it was on October 27, 1908, that fishermen and day-trippers were at the light enjoying the cool autumn season.

Suddenly, an explosion in the surf near some rocks sent up a plume of water. Before anyone could figure out what had happened, there was another, which sent fishermen and sightseer's scrambling for safer ground. Several other blasts followed, and it soon became apparent that the plumes of water reaching skyward were due to artillery shells. As some people huddled near the relative safety of the stone lighthouse, a shell exploded when it struck the northwest corner of the building. Then, as quickly as it had begun, the shelling stopped.

Investigation revealed that the shells were fired by the coastal artillery stationed at Fort Adams in Newport. A red-faced officer explained that the intended target had been a well-known area called "The Dumplings," located about three and a half miles north of Beavertail Light. Fortunately, there were no injuries, and damage to the lighthouse was minor.

CURTAIN CALL

On the evening of January 18, 1901, the Empire Theatre on Westminster Street in Providence was showing a play called *The Power Behind the Throne*. At one point, a man came onto the stage asking, "Is there a doctor in the house?" The request was not part of the play. Apparently, two of the actors had been poisoned during the third act in full view of the audience.

In the play, a wealthy baron and a music teacher's daughter are lovers, and the baron believes she has been unfaithful to him. In the third act, the baron mixes a poisonous powder in a glass of water, and after drinking some of it, accuses the music teacher's daughter of poisoning him. She denies the act, and to prove it, drinks the rest of the potion herself. He then tells her that the poison was real and that both of them will die.

Circumstances are then explained that prove she was never unfaithful to him, but it is too late. The plot twist comes when it is discovered that the poison powder had been switched for sleeping powder by the baron's orderly.

After the curtain closed, the actress playing the teacher's daughter was suddenly stricken backstage. A man identifying himself as a doctor came forward and ministered to her. When he examined the glass from which she had drunk the potion, he saw crystals in the bottom and determined they were most likely oxalic acid, a harmful poison if ingested in sufficient amounts. Before he could be sure that it was oxalic

acid, someone took the glass from him and he never saw it again. He treated the actress with limewater and chalk to dilute the poison, and gave her drugs to restore a regular heartbeat. She later made a full recovery. The actor who played the baron was only mildly affected by the poison. The doctor explained that oxalic acid doesn't dilute well in cold water, and as such, the crystals would have settled toward the bottom of the glass. When the actor playing the baron drank from the top, he only received a small dosage, but when the heroine drank the rest, she ingested the bulk of the poison.

It was clear that someone had switched the harmless sugar powder that was to be used in the death scene with real poison. Who that person was or why he did it was never determined.

ABOUT THE AUTHOR

In the 1970s, when Jim was in high school, he was lucky enough to have a history teacher named Frank McElwain, who had the ability to make learning history interesting and fun. Jim has had an interest in history ever since, and in recent years he has begun trying his hand at writing about it.

Jim is active in the Historical Society of Smithfield and currently serves as vice-president. He also belongs to the New England Antiquities Research Association, and in 2005, he was invited to speak at an NEARA conference about research he had conducted on a colonial-era "ghost town" buried in the woods of Smithfield known as "Hanton City."

This is his second book.

Visit us at
www.historypress.net